plein air PAINTING
IN WATERCOLOR & OIL

Frank LaLumia

NORTH LIGHT BOOKS
CINCINNATI, OHIO
www.nlbooks.com

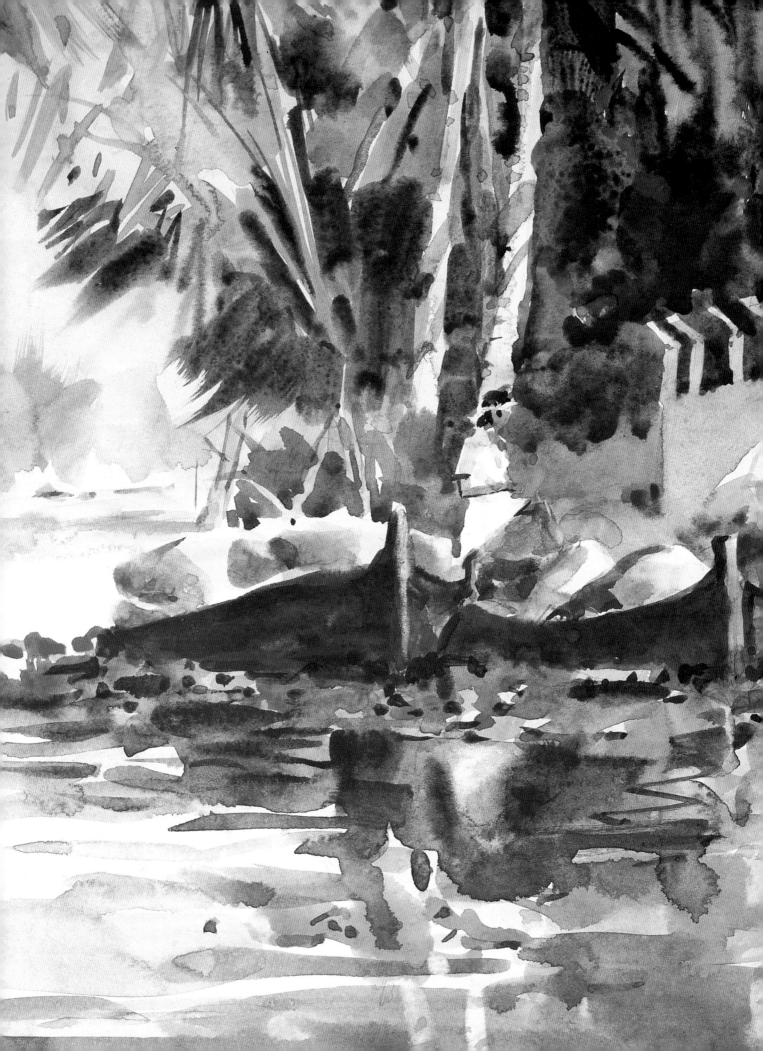

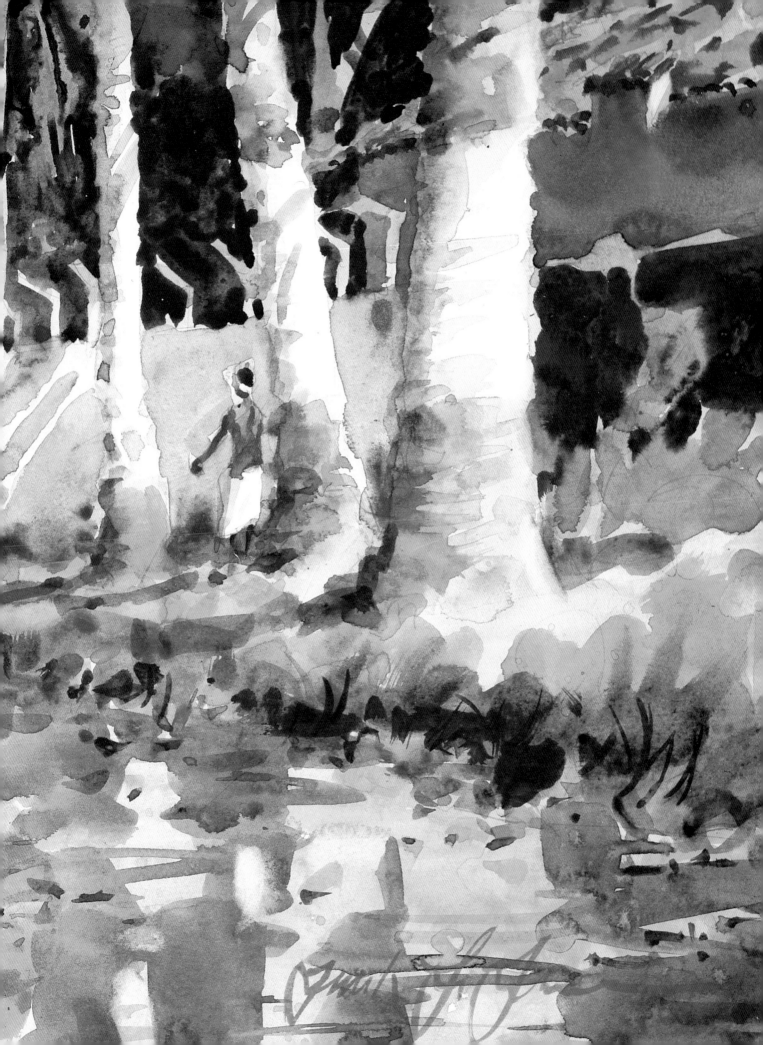

Dedication

This book is dedicated to my mother and father, without whose love and support none of this would have been possible.

ACKNOWLEDGMENTS

I would like to acknowledge my family, friends and teachers who have encouraged and supported me on this long journey. A special thanks to Robert E. Wood and Millard Sheets, and to all of my artist friends, from whom I have learned so much, for we all stand on the shoulders of giants.

I would like to thank the special people who have bought my work and supported me, making my pursuit of art possible. I hope I can live up to your faith in me.

I thank the many art dealers whom I have worked with over the years for believing in me.

Thank you to my many students who have encouraged the writing of this book. Your energy and love of art has inspired as well as taught me a great deal. We are all on the same path.

And finally, I would like to thank my editors, Rachel Wolf, Pam Wissman and Amy Wolgemuth, at North Light Books for their patience above and beyond the call, as well as their help and guidance throughout this project.

THE MALABAR COAST
Watercolor on Waterford 90-lb.
(190 gsm) hot-press paper
11" × 15" (28cm × 38cm)

Plein Air Painting in Watercolor & Oil. Copyright © 2000 by Frank LaLumia. Manufactured in China. All rights reserved. No part of this book may be reproduced in any form or by any electronic or mechanical means including information storage and retrieval systems without permission in writing from the publisher, except by a reviewer, who may quote brief passages in a review. Published by North Light Books, an imprint of F&W Publications, Inc., 1507 Dana Avenue, Cincinnati, Ohio, 45207. (800) 289-0963. First edition.

Other fine North Light Books are available from your local bookstore, art supply store or direct from the publisher.

04 03 02 01 00 5 4 3 2 1

Library of Congress Cataloging in Publication Data

LaLumia, Frank.
 Plein air painting in watercolor & oil / Frank LaLumia-- 1st ed.
 p. cm.
 Includes index.
 ISBN 0-89134-974-X (hardcover : alk.paper)
 1. Landscape painting—Technique. 2.Plein air painting—Technique. I. Title.
ND1342.L27 2000 00-028379
751.42'2436–dc21 CIP

Editor: Amy J. Wolgemuth
Designer: Wendy Dunning
Production Artist: Kathy Gardner
Production Coordinator: Kristen D. Heller

ABOUT THE AUTHOR

Frank LaLumia is a veteran plein air painter of over twenty-five years. Always something of a free spirit, the plein air fire was ignited by a six-month trip to Mexico in 1971, after graduating from Bradley University in Peoria, Illinois. "The stimulation of plein air painting seemed to hold more relevance than classroom situations. Working in the field, however, soon led to the realization of my limited skills as an artist." This resulted in a more academic and disciplined study of art, including a stint at the American Academy of Art in Chicago while Irving Shapiro was director. The attempt to balance a free-wheeling, energetic style of painting within the more disciplined parameters of accuracy is one of the defining characteristics of the work to this day. "It is a lesson that I am still learning."

Frank spent the 1970s in northern California. There was an explosion of creative energy during this period. "California-style watercolors were everywhere, and I was privileged to work with Robert E. Wood and Millard Sheets during those years." In the late 70s, Frank began to seriously study oil painting. "This took me in a completely different direction. As with watercolor, my first impulse was to take it outdoors, which taught me a lot about painting in both media." From that time to present day, oil painting and watercolor have occupied a place of equal importance.

When asked which medium he prefers, he responds with, "It's an impossible choice, like choosing between one's children."

In 1982, Frank moved to Santa Fe, New Mexico. Drawn by the light, the beauty of the landscape and the interesting cultures, Frank's work has been shaped by his environment, "which is ideal for working outdoors in all four seasons."

The love of painting in exotic locales is also a part of Frank, with painting trips throughout the United States and to a number of countries around the world. Whether it is the challenge of painting in third world countries or just looking out his studio window, the important element Frank brings to his art is his attitude. This quality shines through his work, and today, is reaching a growing national audience. Frank is a signature member of the Plein Air Painters of America (PAPA) and the National Watercolor Society (NWS), and he has won numerous awards, both regionally and nationally. His work has been featured in national publications, including *Southwest Art, Art of the West, Watercolor Magazine* and *Watercolor Magic*, and he is represented by galleries in New Mexico, California, Arizona, Colorado, Texas, Wyoming, Oklahoma and Virginia. Teaching is also a part of Frank's life, both from the standpoint of enjoying the company of kindred spirits as well as in the desire to give something back in return for the great blessing, which is the opportunity that we have to pursue our dreams in art.

Frank LaLumia currently resides in Santa Fe, New Mexico. Visit his Web site at www.lalumia.com, or contact him via E-mail at frank@lalumia.com.

TABLE OF CONTENTS

LEFT

SPRING ON THE GREEK ISLAND
OF SIFNOS
Oil on Canvas
18"×14" (46cm×36cm)

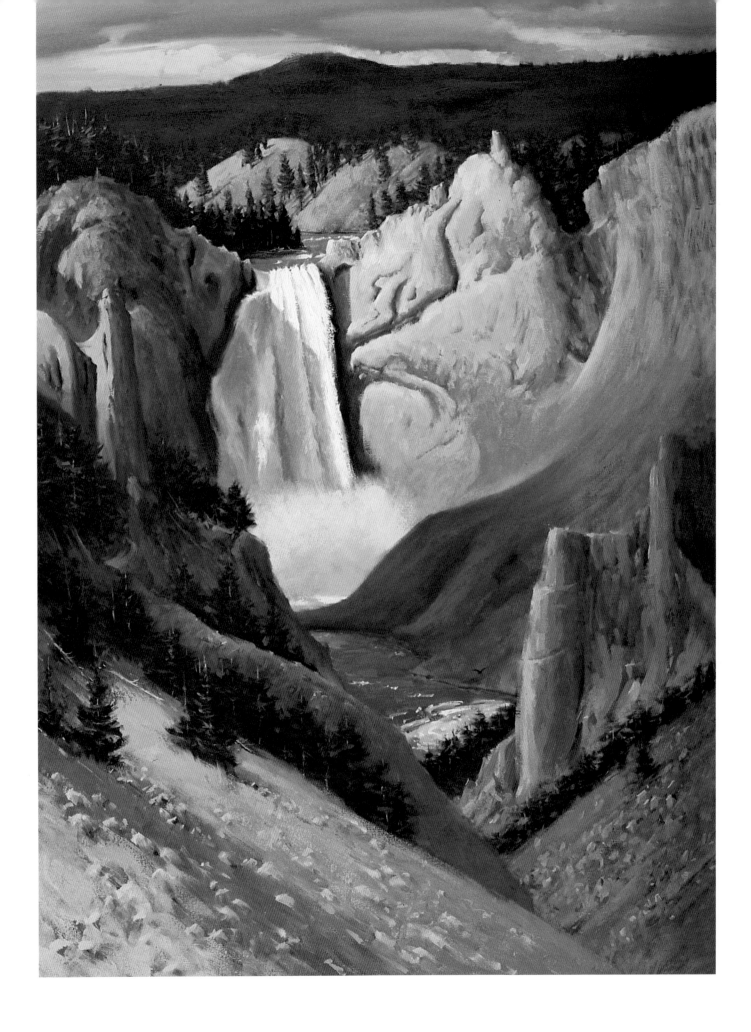

At 5:05 P.M. on September 9, 1977, I quit my last job. With the words of the great watercolorist George Post ringing in my ears, "If not now, when?," I took the plunge and joined the ranks of professional artists. I was scared to death and had no idea if making a living was even possible, but I was burning for art. All I wanted was the opportunity to take my best shot.

The past twenty-three years have brought both fat and lean times, along with countless changes in my work. The path hasn't always been clear, especially in the beginning. But through perseverance, my ideas have clarified into a coherent philosophy that is the foundation of my art. My actual working methods are an attempt to animate this philosophy and its three simple principles.

First is the concept that art is a language, albeit a nonverbal one. We, the artists, study the grammar of this language so that we may communicate more effectively. But like any language, the ultimate purpose lies in the content of the expression, not in the mastery of its usage.

Second is the concept that art is autobiographical. A body of work should reflect the life of the artist. When you draw upon your personal experiences, it naturally follows that you will have something meaningful to say in the language of art.

And third is the concept that working from life is the great teacher. Plein air painting teaches artists how to see, which is the foundation of an individual painting technique. Nature gives up her secrets reluctantly and only to those most determined to crack open the mystery. Consider this quote from the great artist-teacher Charles Hawthorne:

> The only way the artist can appeal to humanity is in the guise of the high priest. He must show people more—more than they already see—and he must show them with so much human sympathy and understanding that they will recognize it as if they themselves had seen the beauty and the glory.

This is what it can mean to be an artist. It is the calling that makes our profession so special.

Painting from life is the moment of truth. If you can paint light, you can paint everything under the sun. This book is designed to help smooth the way. It's really not impossible. And besides, the fun experienced every step of the way more than makes up for any temporary setbacks. Painting from life is the great teacher. It will place you on the road where everything is within your grasp, where all lessons can be learned by those who are both patient and determined. In plein air painting, you will embark on the royal road of creativity. Join me on this wonderful journey!

LEFT

GRAND CANYON OF THE YELLOWSTONE
Oil on canvas
60" × 40" (152cm × 102cm)

I can think of few things in art more thrilling than being in the
right place at the right time and capturing that special moment in a
painting. Whether it's a sunset or a pod of dolphins running with a
ship, when it works it works, and it is very gratifying. All the years
of struggle seem to come together at a single point in time, like it
was all meant for that one moment.

The logistics of plein air painting are critical. The challenge of painting accurate color and value is complicated by the need to work in tempo. Light is constantly changing, creating new relationships between the various elements of the painting. Painting a constantly changing light is like trying to hit a moving target. Good logistics allow full concentration on the painting process itself, rather than struggling with an inconvenient setup.

Simplifying logistics, or having a setup that is simple, lightweight and convenient to use, can make new challenges possible. When your cat falls asleep in the sunlight, you're on it! When your kids are watching television, there is the opportunity to capture that vacant stare. When a great sunset is happening, it's comforting to know that it won't take all day to gather your wits about you, much less your easel and painting gear. In other words, simplifying logistics makes turning your everyday experiences into art easier. Bringing your art into your everyday life can be a critical turning point in the process of becoming an artist and not just a maker of pictures.

I like to think of each on-location experience as a special and magical event. Even the paintings that crash and burn offer great learning opportunities. There are a finite number of plein air paintings left to paint for each of us, and I hate the thought of wasting even one. Good supplies and a good working setup maximize the chance of success for each effort.

The different alternatives presented here have been fine-tuned over years of working in the field. I am indebted to many friends and fellow artists for the free exchange of ideas. My guiding principles are simplicity and being appropriate to the unique challenge at hand. (In other words, the longer the walk, the lighter the gear.) Finding a balance between convenience and portability, two diametrically opposed ideas, is the goal in designing a working setup. I find the logistics of painting in the field to be an endlessly fascinating problem with an infinite number of solutions. The end result is always a work in progress.

TESSA AND THE DOLPHINS
Watercolor on Waterford 90-lb.
(190gsm) hot-press paper
10″ × 14″ (25cm × 36cm)

Materials

In painting, we, the artists, are trying to turn visions into reality. This is difficult enough without adding to it the use of inferior materials. Anything that helps the artist to concentrate more fully on the work at hand is an asset. Using quality art materials eliminates one potential struggle.

PAINTS

Both watercolor and oil paints are produced in artist and student grades. Artist-grade paints have a higher concentration of pure pigments; student-grade paints contain lower concentrations of pigments and more fillers. They are also full of hues. For example, Cobalt Blue Hue is different from Cobalt Blue. Cobalt Blue Hue is made from the pigments Phthalo Blue and Titanium White. True Cobalt is a more expensive pigment and is not contained in Cobalt Blue Hue. Other hues, such as Gamboge Hue, are reformulations, with modern pigments replacing old pigments (Gamboge) that are not permanent. These hues are available in both artist and student grades.

Student-grade paints are lower in price and are useful in the earliest stages of learning. However, there are a number of excellent artist-grade lines that produce paint in large tubes, the economy of which makes them a much better choice than the marginally less-expensive student lines.

Each line of pigments has unique working qualities. Some have a softer texture, while others are stiffer straight out of the tube. This is not necessarily due to a higher or lower concentration of pure pigment. The ratio of pigment to binder is unique to each brand. Working quality, or the texture of a paint, is a major factor to be considered when selecting a particular line of paint. I prefer a professional-grade paint that is softer in texture, which makes the paint easier to mix and use.

Watercolors

I use mostly Da Vinci's large (37ml) tubes (I use a lot of paint!), with a color here and there by Utrecht, Holbein and Winsor & Newton. Da Vinci paints have a nice texture and compare favorably in pigment concentration with other professional lines. They are highly rated in *The Wilcox Guide to the Best Watercolor Paints*, an independent publication with no ax to grind.

Oils

I use Utrecht for many of the same reasons. Utrecht paints contain high concentrations of pigments, and I like the texture. Most colors come in the large (150 ml) tubes, which is economical when you use a lot of paint.

Essential Watercolor Paints for the Plein Air Palette
• Hansa Yellow Light (Lemon)
• Gamboge Hue
• Cadmium Red Light
• Red Rose Deep
• Ultramarine Blue
• Cobalt Blue

Optional Colors
• Cerulean Blue
• Phthalo Blue
• Permanent Alizarin
• Aureolin (Cobalt Yellow)
• Viridian
• Permanent Violet

Essential Oil Paints for the Plein Air Palette
• Titanium White
• Cadmium Yellow Pale (Lemon)
• Cadmium Yellow Light
• Cadmium Red Light
• Quinacridone Red
• Ultramarine Blue
• Pure Cobalt Blue

Optional Colors
• Cadmium Orange
• Viridian
• Cerulean Blue
• Permanent Alizarin

BRUSHES

Watercolor Brushes

Watercolor brushes are designed for challenges different than those of oil painting brushes. There are three requirements of a good watercolor brush. First, it needs to hold a lot of water. Second, the water must flow from the brush at an even and controlled rate. And third, a good watercolor brush needs spring, or the ability of the brush hair to spring back after making a stroke (which includes holding a point or edge).

The best top-of-the-line watercolor brushes are Kolinsky sables. They are very expensive due to the rarity of the raw material. The hair for these brushes comes from the tip of the tails of male Kolinsky sables, minklike animals that thrive in Siberia.

There are many other watercolor brushes made of natural hair, such as squirrel, badger and rabbit, among others. All have admirable qualities, but what they don't have is that great spring of Kolinsky sables. For this reason, they generally make better wash brushes than pointed rounds.

There are many good synthetic brushes on the market that cost a fraction of the price of a Kolinsky sable. Synthetic hair is great at holding large amounts of water. It also has excellent spring and holds a point longer than sable. However, synthetic hair brushes aren't as effective at allowing free and even flow of water. Water flows out of synthetic hair faster, which makes a wash more difficult to control. Synthetic brushes take a little getting used to, but they can substitute for Kolinsky sables. I particularly like using a large, round synthetic brush, such as the no. 36 Goliath round by Robert Simmons.

There is also a new generation of watercolor brushes that are made from a combination of synthetic and sable hair. Most of these have a belly of sable hair in the middle of the brush designed to hold a lot of water. The hair around this reservoir is synthetic and is designed to hold a point longer than pure sable. These Pro-Arte brushes perform very well at a fraction of the price of Kolinsky sables.

Cleanup and care for watercolor brushes is simple. Just wash them out with clean water and let dry. Do not leave any brush in water resting on its point for even a short time. Not only is it bad for the point, but the water will also cause the wood around the ferrule (metal portion of the brush) to expand. When the wood later dries, the ferrule will be loose on the handle. (Note: Sable hair is more delicate than synthetic hair. Never use soap to clean sable hair brushes.)

Essential Brushes for Plein Air Watercolors

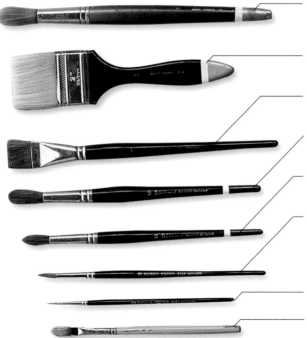

No. 36 Goliath round synthetic hair (Robert Simmons). I use this brush occasionally as a wash brush, particularly in the early block-in stages of a watercolor.

2-inch (51mm) Skyflow wash (Robert Simmons). This is my main wash brush used in the early stages of most watercolors.

1-inch (25mm) Kolinsky sable flat (Jack Richeson). This brush is useful for all stages of a painting.

No. 16 round sable/synthetic blend (Pro-Arte). Large rounds are particularly useful during the early and middle stages of a painting.

No. 12 round sable/synthetic blend (Pro-Arte). This is also a very useful brush for all stages of painting.

No. 8 round Kolinsky sable (Jack Richeson). I prefer Kolinsky sables as small rounds. These are particularly useful for drawing and other fine work.

No. 3 round Kolinsky sable (Jack Richeson). This brush is useful for fine detail work at the end of a painting. I usually don't use a brush this small for most watercolors, but it is handy when needed.

No. 6 filbert bristle brush (Robert Simmons). This one is useful for softening edges. Note that the handle has been cut off so it will fit into a watercolor Pochade box (see page 22).

Oil Painting Brushes

Good quality brushes are very important in giving yourself the best possible chance for success. Oil brushes are cheaper than watercolor brushes, primarily because the raw materials cost so much less. Most manufacturers make a number of different lines of brushes. I highly recommend buying top-of-the-line artist-quality brushes. Some of the brands I prefer are the Winsor & Newton Rathbone series, the Grumbacher Gainsborough series, the Robert Simmons Signet series and the Utrecht Rhenish series.

Oil painting brushes are made with a number of materials. Generally speaking, there are two different types: soft hair brushes (sable as well as a number of synthetics) and bristle brushes. The *soft hair brushes* are useful for thin, fine painting, usually in a more

rendered, detailed style and with an oil medium or thinner. *Bristle brushes*, on the other hand, are the most common and versatile tool of the oil painter. It is easier to mix thick-textured oil paint with bristle brushes. Bristle brushes come in several basic shapes, including brights, flats, filberts and rounds.

Brights are flat brushes that are basically square-shaped; that is, the length of the bristle is the same as the width. They're particularly good for mixing thick paint as well as scrubbing in.

Flats are also flat in shape, but the length of the brush is approximately 2 to 2½ times that of the width. The large ones are good for covering big areas, and small flats are useful when drawing.

Filberts are like flats with rounded corners. They're good for drawing, and they make strokes that are less chiseled than strokes from flat or bright brushes.

Rounds are just that. The larger ones are good for block-ins, while the smaller ones are useful for drawing. Small sable rounds work well for fine drawing.

To maximize the life of my bristle brushes, I wash them with kerosene rather than mineral spirits or turpentine. Kerosene is the least harsh of the solvents. Mineral spirits and turpentine burn the bristles over time, causing the brushes to lose their natural moisture content. Kerosene has a slight natural oiliness that delays that effect, prolonging the life of the bristles. In addition, I occasionally wash out my bristle brushes with soap and water. Perhaps I should do this more often, but soap also has a harsh drying effect over time. Generally, I wash out my brushes when needed.

Essential Brushes for Plein Air Oils

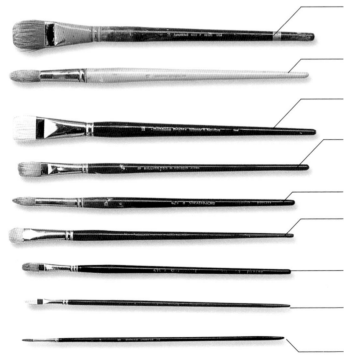

No. 14 flat bristle (Langnickel). This is used for the early block-in stages, as well as for painting large shapes, such as skies, foregrounds and so on.

No. 12 round bristle (Utrecht). I like this brush, especially for blocking in and for painting large shapes.

No. 12 bright bristle (Winsor & Newton). This brush is useful for painting impasto paint over large areas.

No. 8 flat bristle (Holbein). This is a good medium-size brush, useful for drawing and painting in the middle to late stages of a painting.

No. 8 round bristle (Strathmore). This one is useful for drawing and bringing an image into focus.

No. 8 bright bristle (Winsor & Newton). This is another useful midsize brush that is particularly good for mixing paint and painting impasto passages.

No. 4 filbert bristle (Strathmore). I like the small filberts for carefully drawing and finishing work.

No. 2 filbert bristle (Winsor & Newton). This is another handy brush for finishing work.

No. 8 round Kolinsky sable (Utrecht). Useful for fine drawing, I don't use this brush on every painting, but it can be handy when needed.

OTHER ESSENTIAL MATERIALS

Palettes

Watercolor — I use two watercolor palettes. The more portable one is an enameled-tin folding palette made by Holbein (A). It's very portable. When folded, it fits conveniently into both my watercolor Pochade box and the half-size French easel (see watercolor logistics in this chapter). There is a convenient thumbhole for holding the palette, which comes in handy with one of my portable setups. The palette comes in three different sizes, and I use the largest.

I also use a John Pike palette (B). It's not as portable, but it does have a large, open mixing surface. It is made of a higher-quality plastic than the average palette, which makes it tough and durable. I use it with my full-size French easel setup, particularly for plein air 22″ × 30″ (56cm × 76cm) full sheets and also 15″ × 22″ (38cm × 56cm) half sheets.

A
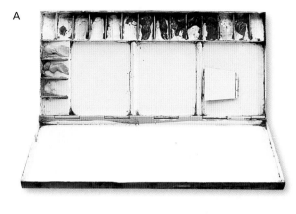

B
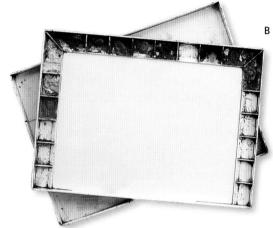

Oil — I prefer mixing oil paint on a surface of nonglare glass. The primary advantage is the ease of cleanup: one stroke of a glass scraper is all that it takes. Nonglare glass is handy outdoors in that it reduces glare and the resulting eye strain. Even in the studio, it helps cut down the reflection of indoor lighting. As palettes aren't available with this option, I have adapted them by attaching the nonglare glass to a surface of mahogany plywood with silicone glue.

Water Containers

My two water containers are adapted food-storage units. The larger one is used with my full-size French easel (see pages 26–27). The nylon cord hanging from the side is carefully measured to hang from a screw inside the open drawer of the easel. The container was chosen both for its volume (it takes a half-gallon of water) as well as for its square shape, which allows it to rest more comfortably against the side of the easel drawer.

The smaller container is used with both the watercolor Pochade setup (page 22) and the half-size French easel watercolor setup (page 24). I use two small S-hooks, crimped down on the water container, to mount it to both watercolor setups.

Masking Fluid

Although I have masking fluid in my studio, I rarely use it and almost never bring it along when painting on location. The objection I have to using masking fluid is that the effect is so obvious on the face of the finished work. The giveaway is the razor sharp edges that it produces, which is usually jarring within the context of the painting. I think it's distracting when a pure-

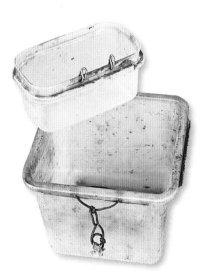

ly technical effect jumps forward in a prominent way (I can spot the use of masking fluid from across a room). I have the same objection to the use of salt, alcohol and many other watercolor textural devices.

I have experimented with masking fluid and have even used it effectively on a few occasions. By softening edges with a bristle brush after the masking fluid has been removed and before you resume the painting, you can hide your tracks in the sense that the effect is more integrated into the painting. However, I usually find it to be more of a hassle than it's worth. I prefer painting around an area to masking it.

Turpentine, Mineral Spirits and Other Oil Painting Mediums

The advantage of thinning oil paint with turpentine is that the turpentine evaporates at a slightly faster rate than mineral spirits. But the difference is slight, and turpentine is much more expensive. I rarely use turpentine anymore, but I do use it to thin my oil varnish. It seems to be a better solvent for that purpose than mineral spirits.

I use just enough mineral spirits for thinning and loosening my oil paint during the earliest stages of a painting. Scrubbing in the underpainting is a better option than having mineral spirit-thinned paint drip and run all over. Besides, too much thinning compromises the binder (oil) in the paint.

For an oil medium, I mix stand oil and turpentine (or mineral spirits) in a ratio of approximately 40 percent oil to 60 percent solvent and use only when painting *impasto paint* (thick paint straight from the tube) over impasto paint. In many pieces I don't use it at all, although I always carry some along just in case.

Tissues and Paper Towels

This is an important part of the logistical gear for plein air painting. Controlling the mess and chaos is important in staying on track to your goal. Tissues, such as Kleenex, work well when painting with watercolors. Tissues pick up paint as well as absorb excess water. Remember: if you intend to control watercolors, you must control the water. Tissues will help.

When oil painting, paper towels work well. Absorbency is not as important, and paper towels are more durable. I buy the rolls that tear off in half-sheets, regardless of the brand.

Garbage Bags

With both media, use plastic garbage bags attached to your easel setups with black binder clips. Keeping everything in order is important to staying focused.

Daypack

It's hard to find good daypacks. The main criteria are volume and ease of use. I prefer the open-top style that close with a flap that buckles down over the top. My favorite daypack is the larger of two continental rucksacks sold by L.L. Bean.

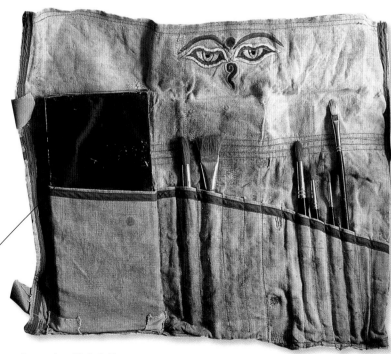

Daypack with Palette

Painting Surfaces

Watercolor Paper — At any given time, I keep a number of different surfaces and brands on hand. Watercolor paper comes in three different surfaces: rough, cold-press (medium texture) and hot-press (smooth texture). Rough paper is an acquired taste for most watercolorists. The texture of the paper breaks up brushstrokes more readily, unlike smoother paper, keeping large washes from spinning out of control.

Cold-press is the most popular surface among watercolorists. The light texture makes handling a wash easier than on hot-press. Fabriano Esportazione cold-press, a handmade paper, not only has good lifting possibilities (ability to lift dry paint), but its random-textured surface also takes wet-into-wet and repeated washes well. (Note: The 147-lb. (313gsm) sheets will buckle after a certain degree of wetness, therefore requiring stretching.) Kilimanjaro cold-press, on the other hand, works best with more controlled techniques. Due to its soft surface, it doesn't handle repeated wet-into-wet washes or the rigors of working outdoors very well.

Hot-press is the smoothest paper and it is more difficult to use. I like Winsor & Newton's hot-press, which is slightly more textured than the aver-

age hot-press. It's an excellent sheet for plein air painting, particularly in smaller sizes, such as 11" × 15" (28cm × 38cm). I also use Waterford's 90-lb. (190gsm) and 140-lb. (300gsm) hot-press sheets.

Your choice of paper should be an intuitive response to a particular subject. A beautiful watercolor is dependent on a fine surface. Many of the cheaper papers have boring, gridlike surfaces that detract from the painting. Look for an attractive, random-surfaced texture. Also, when on location, use tough (hard-surfaced) paper to endure the rigors of working in the field. Arches is my favorite all-purpose paper for painting on location. It is tough, durable and takes paint very well in repeated wet-into-wet applications as well as when dry. It could be sized a little more

heavily for my taste as well as a little whiter. Nevertheless, the pluses far outweigh the minuses. Arches is reasonably priced and a good choice.

Watercolor Sketchbooks — For quarter-sheet watercolors, 11" × 15" (28cm × 38cm), I make my own sketchbooks. These books are easy to make. ① Quarter a full 22" × 30" (56cm × 76cm) sheet. ② Using a three-ring hole punch with the middle punch removed, punch holes in each sheet. (I made a template that the hole punch rests on while cutting so that the holes properly align.) ③ Use four-ply, 100-percent rag mat board for the covers of the book and ④ bind it together with book rings (approximately the diameter of a quarter). ⑤ Use four binder clips on the corners of the sketchbook, to hold the

SELECTING THE RIGHT PAPER

The most common weights are 90-lb. (190gsm), 140-lb. (300gsm) and 300-lb. (640gsm). Heavier weight paper will enable you to overpaint (sometimes four or five wet-into-wet washes) without the paper buckling. If you are planning on painting a half sheet or larger and there will be a lot of wet-into-wet, then I recommend using 300-lb. (640gsm) paper. A good average weight that works well in most conditions is 140-lb. (300gsm). Because 90-lb. (190gsm) paper saturates and buckles more easily than heavier papers, it is best saved for smaller-scale paintings.

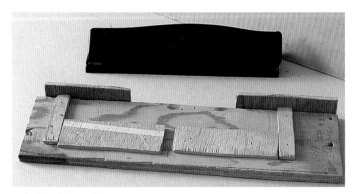

Hole Punch Template

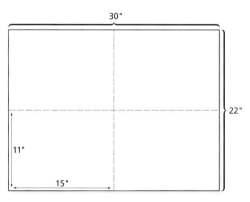

Quartering Your Paper

pages in place as you paint.

These sketchbooks have many advantages. The first is paper selection. Another is that they are light and easy to use. Try carrying two sketchbooks, each with four or five sheets. That way you will be able to start a second painting while the first one dries. Quarter-sheet books are a great alternative to using blocks.

Canvas — I like smooth surfaces for my canvas and have picked out two types that work well for different purposes. The first is a Belgian linen with an average to light texture, made by Claessens, with a double oil-primed surface, primed by Utrecht. It has a moderate texture, and it stretches very nicely. I use this canvas for paintings greater than 16″ × 20″ (41cm × 51cm).

For my panels and smaller pieces, I use Fredrix Red Lion, a polyflax, acrylic-primed canvas. I like the way it takes paint, particularly in washes and thinner applications, and its fairly smooth surface yields attractive transparent passages. While it has poor tensile strength (it doesn't stretch very well), it is stronger and more dimensionally stable than linen or cotton (it doesn't expand and contract in humidity). Overall, Red Lion canvas makes an excellent small panel.

Making a panel is easy. Use a roller to apply white glue to an ⅛″ (3mm) plywood panel's surface. (To avoid warping the panel, first wet the other side with a sponge and clear water before applying the glue.) After adhering the canvas, let the panel dry under a weight for twenty-four hours. The result is an excellent flat, lightweight canvas panel.

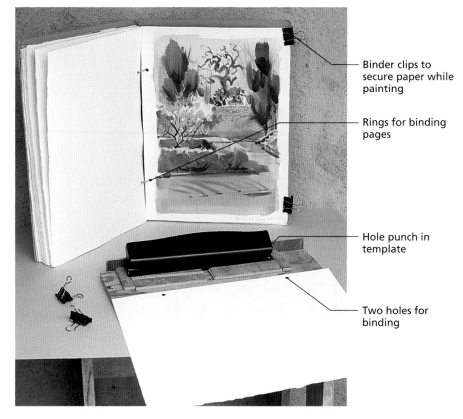

Binder clips to secure paper while painting

Rings for binding pages

Hole punch in template

Two holes for binding

Canvas

Plywood Panel

Watercolor

Ever arrive on location having forgotten your palette? If not, you are the only one who hasn't. The following checklist will help avoid such minor disasters.

Paints
- Da Vinci Watercolors
 - Red Rose Deep
 - Ultramarine Blue
 - Cobalt Blue
 - Hansa Yellow Light
 - Gamboge Hue
 - Cadmium Red Light

Optional Colors

Choose your colors depending on the prevailing light, season of year and other subjective considerations. Sometimes they can be anticipated, and other times they will arise spontaneously.
- Utrecht Watercolors
 - Viridian
 - Pure Cadmium Orange
 - Phthalo Blue
 - Permanent Violet
- Winsor & Newton Watercolors
 - Cerulean Blue
 - Aureolin (Cobalt Yellow)
 - Permanent Alizarin

Brushes
- 2-inch (51mm) wash
- 1-inch (25mm) sable flat
- Nos. 3, 8, 12 and 16 rounds
- No. 4 or 6 filbert

Optional Brushes
- No. 36 Goliath round

Paper
- Quarter-sheet, 11" × 15" (28cm × 38cm), watercolor sketchbook with rough, cold-press and hot-press sheets
- Half-sheet, 15" × 22" (38cm × 56cm), drawing board with a sheet of Arches 300-lb. (640gsm) watercolor paper

(Note: Mount the paper to the drawing board with masking tape on all four sides. Tape a piece of cardboard over the watercolor paper to protect the surface of the paper. Once on location, remove the board.)

Other
- Daypack (into which everything fits)
- Easel and palette
- Water and water container
- Sketchbook and pencil
- Binder clips (four)
- Masking tape
- Tissues
- Plastic garbage bag
- Clip-on umbrella
- Hat with sun visor

Oil

Does it seem to take longer to get ready to go painting than it took Michelangelo to block in the Sistine Chapel? If so, the following checklist will help in your preparations.

Paints
- Utrecht Oils
 - Cadmium Red Light
 - Ultramarine Blue
 - Pure Cobalt Blue
 - Cadmium Yellow Pale
 - Cadmium Yellow Light
 - Titanium White
- Grumbacher Oil
 - Quinacridone Red

Optional Colors
- Utrecht Oils
 - Viridian
 - Cerulean Blue
 - Cadmium Orange
 - Permanent Alizarin

Brushes
- No. 14 flat
- No. 12 bright and round
- No. 8 bright and flat
- Nos. 2 and 4 filberts
- No. 8 round
- No. 8 sable round

Optional Brushes
- No. 6 round
- No. 6 filbert
- Nos. 6 and 10 brights and flats

Canvas
- A few panels with corresponding storage capacity. (A Pochade box has a built-in storage capacity for a few wet oils.) When I am working on a larger scale, I bring along a day drybox that holds up to five wet oils. For example, a 12" × 16" (30cm x 41cm) drybox will accommodate panels with a common 12" (30cm) side, including 9" × 12" (23cm x 30cm), 12" × 16" (30cm x 41cm) and so on.

Other
- Easel and palette (or Pochade box and tripod)
- Drybox
- Sketchbook and pencil
- Binder clips (four)
- Glass scraper
- Palette knife
- Mineral spirits
- Paper towels
- Plastic garbage bag
- Hand cleaner
- Brush cleaner
- Clip-on umbrella
- Hat with sun visor

Portable Watercolor Setup

My most portable watercolor setup was designed for working abroad. Through trial and error, I came up with a simple tripod-drawing board design that allows me to set up, do a painting and break down within thirty minutes. Not only does this setup work under adverse conditions, such as painting while standing in surging crowds, but it also works well at home.

MAKING YOUR OWN DRAWING BOARD

The drawing board is simple to make and is designed to support quarter-sheet watercolors. ① Use an 11 ½″ × 15 ½″ (29cm × 39cm) ¼″ (6mm) piece of mahogany plywood. (⅛″ (3mm) masonite works just as well), and adapt it with a camera tripod mount. ② On the back side of the board, glue and screw on a small piece of plywood to provide support to the ¼″ (6mm) nut that will receive the tripod. Measure the thickness of the board plus the support piece to determine the length of the nut you need. They are available at most hardware stores and are easy to install. ③ Drill holes on the left side to hold brushes and a small hole at the bottom (center) for hanging a water container. ④ Using glue, add a narrow piece of wood to the bottom of the board for a sketchbook rest. (I prefer to have the book resting on the board without it being clamped down, as I often will turn it upside down to manipulate the flow of water and thus the whole drying dynamic.) ⑤ Cut out two small rectangles at the bottom right and left of the board. When necessary, such as in windy conditions, you can use black binder clips to clamp the book to the board.

Front View

Back View

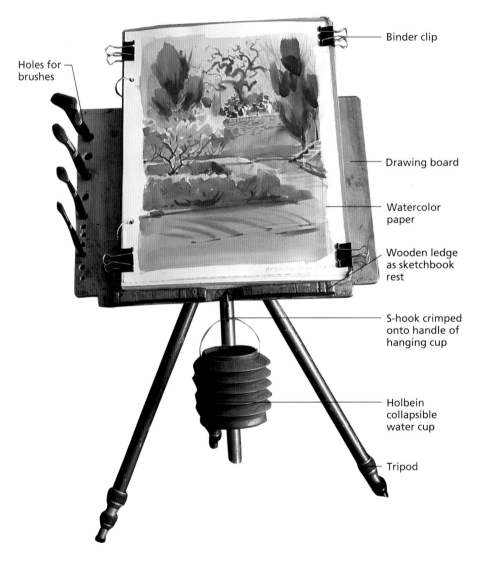

Holes for brushes

Binder clip

Drawing board

Watercolor paper

Wooden ledge as sketchbook rest

S-hook crimped onto handle of hanging cup

Holbein collapsible water cup

Tripod

SETTING UP AND BREAKING DOWN

When setting up and breaking down, lay the board flat and use it as a table. (This makeshift table is convenient for carrying out many small tasks, such as squeezing out color onto your palette and cleaning brushes.) The outfit is very easy to set up and break down, requires only a light tripod and it fits easily into a daypack. Although it was designed for foreign travel, I frequently use it in my studio. Sometimes I keep the loaded daypack in the trunk of my car. It's great for spontaneous moments when life takes one of those delicious little turns. Once I painted a watercolor of a used car lot when my car broke down and was being repaired.

A Successful Painting

This watercolor was painted from inside the Temple of the Masks, looking across at the Temple of the Gran Jaguar, using a portable tripod-drawing board setup. It was a little dark inside the temple, but I was able to turn to get enough light across the paper. The logistics of my setup was particularly appropriate, given all the hiking and climbing to get there, as well as the close quarters inside the temple. Using this setup, I am able to paint with freedom and always feel that for any given painting I have a chance.

TIKAL
Watercolor on Waterford 90-lb. (190gsm) hot-press paper
14″ × 10″ (36cm × 25cm)

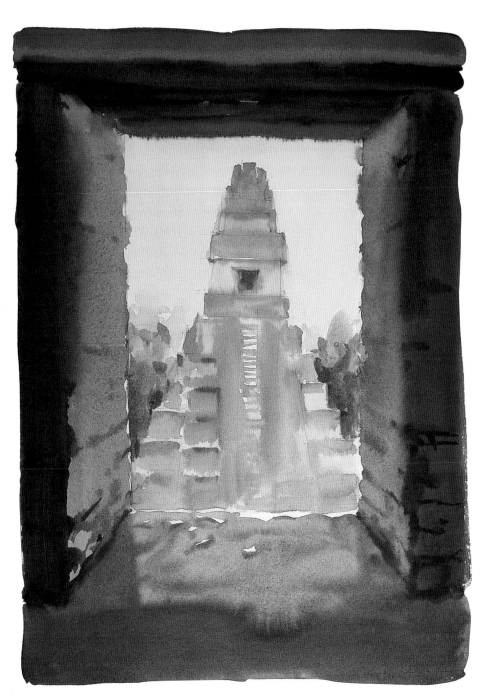

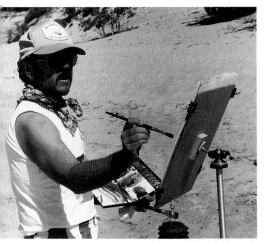

Photograph by David LaLumia

Painting on Location

In this setup, I'm painting a little more vertically than usual, an adaptation to wind and sun. Under normal conditions, I paint vertical pieces by resting the book (vertically) on the horizontally oriented drawing board as opposed to clamping it to the board as in this photograph. The collapsible water cup is hanging from the bottom of the board, and I'm holding a Holbein enameled-tin palette. Getting accustomed to holding my palette was easier than expected and I have grown to enjoy it. To remove excess water, simply turn the palette over and shake. (It's also effective for crowd control!)

Watercolor Pochade

This portable watercolor setup utilizes a modified oil painting Pochade box (see page 28). While it is a little heavier than the tripod-drawing board setup, it still easily fits into a daypack. You can use the same tripod as with the drawing board-tripod setup, and the brushes and palette fit inside the box. The greatest advantage, and the reason I developed it, is that it has an umbrella mount. This makes all the difference in conditions of sun, heat and low humidity.

The Pochade box was originally created for 9″ × 12″ (23cm × 30cm) panels, with the top of the box notched with two slots for wet oil panels. I use these notches as the bottom support piece that holds the sketchbook as well as to store the black brush holder (that fits on the left side of the box). The bottom piece remains in this position for use while painting.

① For the umbrella mount, attach a round dowel to each side of the box's bottom. (You can cut these pieces from an old broom handle, then screw them into place from the inside of the box, using two screws per dowel.) By having a dowel on each side, you will be protected from the different positions of the sun. ② Attach the C-clamp of the umbrella to the dowels, resting the umbrella stem on the small pieces of metal (one on each side) mounted on the top half of the box. These metal pieces have two purposes. The first purpose is to clamp the umbrella stem to the box with a black binder clip, thereby making it more stable, as well as getting the umbrella stem out of the way of the swinging brush. The second purpose is to secure the sketchbook to the box (again with a black binder clip) in conditions of wind or whenever necessary. ③ When the box is set up for painting, secure the black brush holder to the left side with two binder clips clipped to a small metal angle (attached permanently to the black piece) and then clip to the side of the Pochade box. ④ For the water cup, use any

small, plastic container. (I used a Rubbermaid storage container.) Drill two holes and attach two small S-hooks (crimped down on one end so they don't get lost). On the right side of the box, add two small screw eyes, carefully placing to receive the S-hooks of the water cup.

This daypack setup is light and simple, easy to set up and it offers sun protection under moderate wind conditions. What more could you ask for?

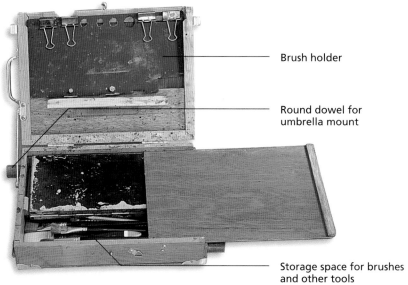

Brush holder

Round dowel for umbrella mount

Storage space for brushes and other tools

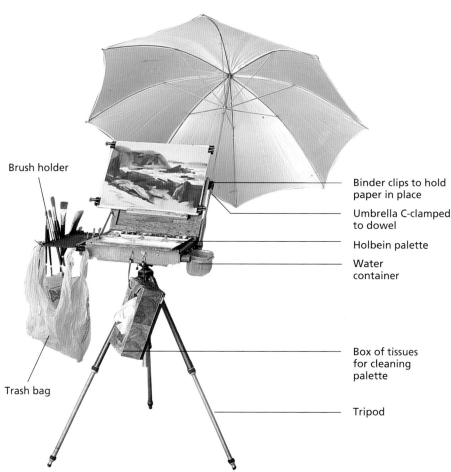

Brush holder

Trash bag

Binder clips to hold paper in place

Umbrella C-clamped to dowel

Holbein palette

Water container

Box of tissues for cleaning palette

Tripod

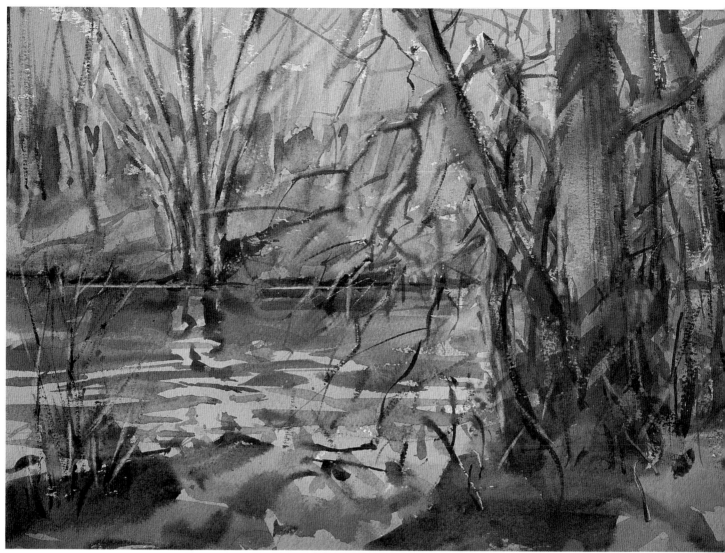

The challenge of this piece was simplifying the complex maze of elements while staying focused on the glorious quality of late-autumn afternoon light. My watercolor Pochade was the perfect choice of setups, allowing for the use of my white umbrella in open sunlight. This particular setup is also an effective solution to the problem of minimizing the weight and volume of painting gear while maximizing the chances of a successful painting.

LATE AUTUMN ON
THE GRAND RIVER
*Watercolor on Arches 140-lb.
(300gsm) rough paper
11" × 15" (28cm × 38cm)*

Half-Size French Easel Watercolor Setup

Another favorite watercolor setup of mine is an adapted half-size French easel. While it is not as portable as the tripod-drawing board setup or the watercolor Pochade box, it still works as carry-on luggage on an airplane. I use the half-size easel for 15″ × 22″ (38cm × 56cm) watercolors, and even 22″ × 30″ (56cm × 76cm) full sheets under optimal conditions. One of its most important features is the umbrella mount. Sun protection is critical when painting watercolors outdoors. When working on a half-sheet or larger, it is absolutely essential that the sun not strike the paper directly. Direct sun plays havoc with the drying time, ruining any chance to create a good variety of edges, and it makes the white paper blinding. The half-size French easel provides a solution to that problem.

To handle the problem of sun, use a simple white umbrella with a built-in C-clamp on the end. The clamp can be attached to the easel itself or to a stick used as an extender. The piece of wood (my extender) is attached to the easel with a C-clamp, then the umbrella is clamped to that. The umbrella also has a flexible elbow at the end that will allow you to adjust it (in a limited way) for better coverage.

While a white umbrella won't provide shade and its use is limited in windy conditions, it will filter the sunlight and offer just enough protection to give you a fighting chance. You will find that it can make the difference between the success or failure of a painting.

The palette is the same Holbein enameled tin as used in the tripod-drawing board setup, but here it has been secured to the top of the open drawer by a small bungee cord running behind the easel. The palette is off-center by design. The water cup, leaning against the side of the open drawer for support, is hooked onto the palette with two small S-hooks that have been crimped down on the plastic cup so they won't get lost.

A piece of ⅛″ (3mm) plywood serves as a brush holder. Its main function is to keep the contents of the drawer from spilling out when the easel is upright. I removed the easel's original folding wooden oil palette, replacing it with a folding Holbein palette, which fits the width of the drawer perfectly. However, because the drawer is longer than the palette, the piece of ⅛″ (3mm) plywood is used to compensate. I have adapted it for double use by drilling holes in one end and using it as a brush holder.

This setup is very effective. It offers limited but sufficient sun protection, and it all fits into a daypack. The test of any given setup is to have the feeling that anything is possible. You don't want to lose a painting due to bad logistics.

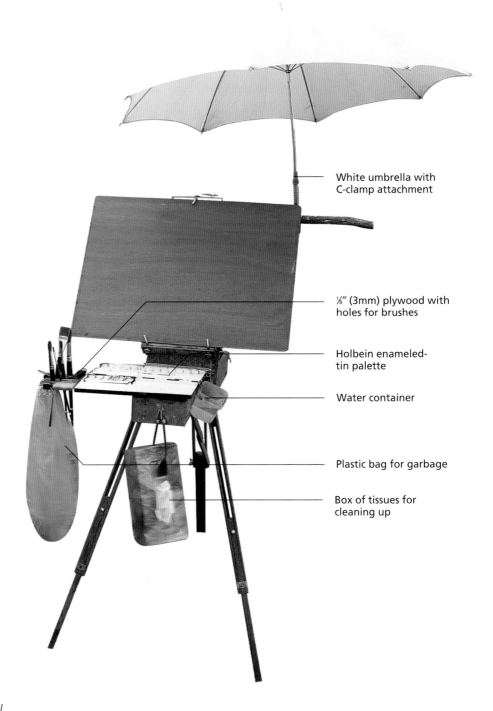

White umbrella with C-clamp attachment

⅛″ (3mm) plywood with holes for brushes

Holbein enameled-tin palette

Water container

Plastic bag for garbage

Box of tissues for cleaning up

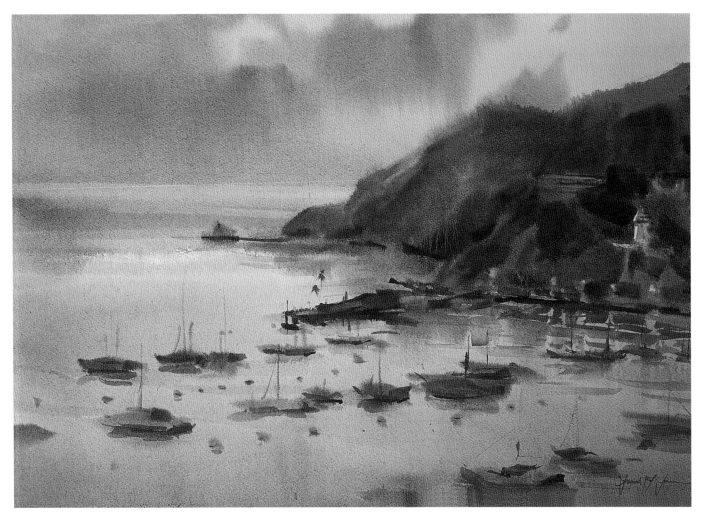

A Half-Sheet Watercolor

This watercolor was painted using the half-size French easel described on the previous page. The spot was preselected, and I arrived well before sunrise. It was fairly dark while setting up, but by the time daylight first appeared, I was ready. Light changes very quickly at that early hour, and to do a piece of this size requires a quick, decisive approach.

Painting quickly increases the odds of making a mistake, therefore concentration needs to be even more focused. Painting the fleeting effects of light is great fun, but also very demanding. It is worth practicing, for when you paint a good one, it can really be something special.

SUNRISE, CATALINA
Watercolor on Arches 140-lb. (300gsm) cold-press paper
15″ × 22″ (38cm × 56cm)
Private collection of Mary and Robert Barrick

HELPFUL HINTS

Each watercolor setup has its own purpose, and each is designed for a particular challenge. Remember:

- Painting a half-sheet watercolor is much more logistically complicated than a quarter sheet. While the half-size French easel works fine for smaller paintings, I prefer using the lightest and simplest gear possible for any given painting. For 11″ × 15″ (28cm × 38cm) quarter sheets or smaller, consider trying the tripod-drawing board setup or the watercolor Pochade setup.

- Keep your different setups permanently stored in their own daypacks. This simplifies a day's preparation. Sometimes there is a common element, such as brushes, that needs to be shifted from one daypack to another, but keeping each set of logistical gear in its own place simplifies preparations for a plein air session.

Logistics for Large-Scale Watercolors

I find that the best logistics for a large-scale watercolor, 22″ × 30″ (56cm × 76cm), is a full-size French easel. Use a white clip-on umbrella, as previously described, and a John Pike palette, which has a larger mixing area. The brush holder is the palette that comes with the easel (a piece of masonite that also keeps the contents of the drawer in place when the easel is upright). You can adapt it for double use by drilling various-sized holes in one end and using it as a brush holder. The water container also needs to be larger. You will need a lot of paint to do a full sheet, and that means a lot more of it ends up in your water. A larger container means less changing of water mid-painting. The plastic water container should be square on top so that it rests more firmly against the side of the drawer. Hang the water container from a single screw inside the drawer on the right-hand side (see page 27). In the middle-top portion of the container, drill two holes and string it with a thin piece of nylon cord, tied very carefully. If the loop is too big, the contain-

er will swing too much when cleaning brushes. If the loop is the right length, however, the container will be stabilized by the side of the drawer as it hangs.

Before heading off to paint, mount two full sheets, one on each side, to your drawing board. Next, tape a piece of cardboard over each sheet. Often there's a short walk involved, some-

times through high grass or brush, and the cardboard protects the delicate surface of the paper from becoming scratched or marred. On site, remove the cardboard; when finished, replace it. (Carry a roll of masking tape for that purpose.) This will help increase your chances of success under the most difficult of circumstances.

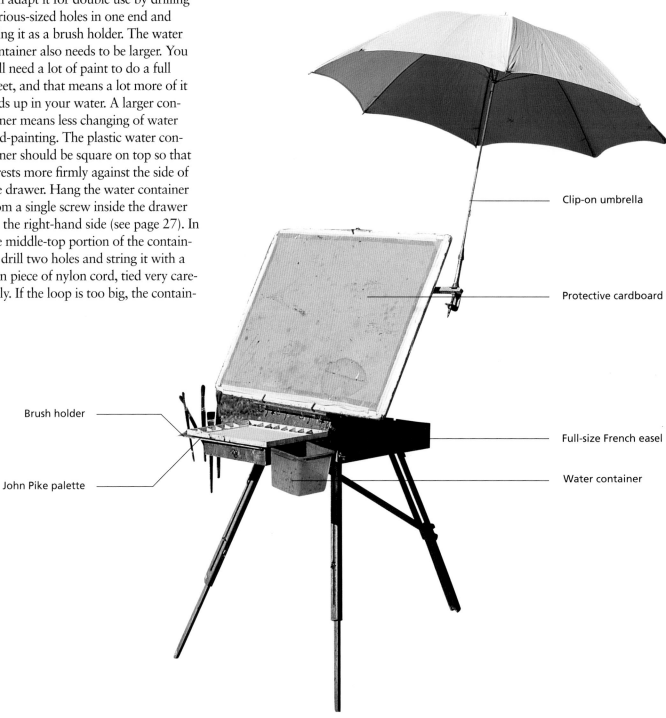

Clip-on umbrella

Protective cardboard

Brush holder

John Pike palette

Full-size French easel

Water container

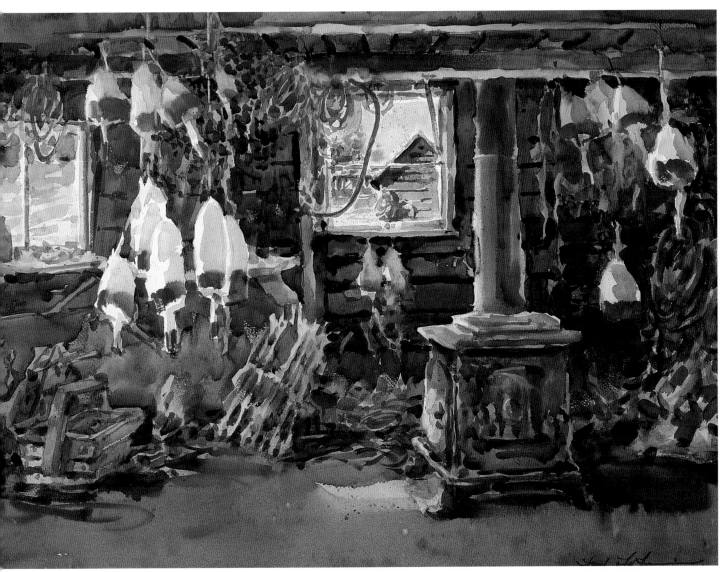

A Full-Sheet Watercolor

Painting a full-sheet watercolor on location is not always easy. Factors such as relative humidity are critical (see pages 58–59). A full sheet en plein air is more difficult in the desert than it is on the beach. But when the conditions are optimal, as they often are on the coast, it is more fun than can be described. It's a very physical act, with paint flying in all directions, and it requires good logistics along with a little luck. This setup offers maximum stability, and it makes doing a full-sheet painting possible.

IN THE BAIT HOUSE OF A
MAINE LOBSTERMAN
*Watercolor on Fabriano Esportazione
147-lb. (313gsm) cold-press paper
22″ × 30″ (56cm × 76cm)*

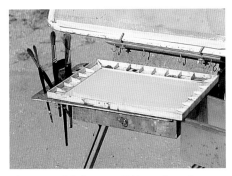

Close-ups of Palette and Water Container

Portable Oil Painting Setup

There are a number of excellent solutions to the problem of portable oil painting setups. With the explosion in popularity of plein air painting over the past few years, there are now more products than ever designed for plein air oil painters.

POCHADE BOXES

Pochade boxes of all sizes and styles are the most popular and convenient way to go. What they all have in common are the adaptation of a built-in camera tripod mount, as well as storage space within the box for a few wet paintings. They are perfectly adapted to travel and are also convenient for home and studio use.

The Open Box M Pochade (by Open Box M) is one of the most elegantly designed products I have ever used, and it is a favorite among professional artists. The materials used are first class. The box is made of solid black walnut with brass hardware. The palette, with its camera tripod mount, fits inside a larger box. The bottom of the box contains storage space for paints and brushes, while the top has storage space for four wet panels (two notches for back-to-back storage of ⅛″ (3mm) panels. This space is adjustable for different size panels.

There are a number of innovative design features that really put the competition in the shade. First, the palette can be used with a lighter tripod, as the tripod isn't required to support the weight of the entire box, including tubes of paint, panels and so on.

Another great feature is the method of securing the panel while painting. The box has a spring clamp that enables the artist to raise or lower the panel while painting. There is also a built-in work area on the left side of the palette. This piece is securely stored under the palette when packed away inside the box.

You may want to consider drilling a few holes of various sizes to serve as wet brush holders and increase its ease of use. Also, adding a palette of nonglare glass will enable you to clean it with one stroke of a glass scraper.

The boxes are available in three sizes: 8″ × 10″ (20cm × 25cm), 10″ × 12″ (25cm × 30cm) and 11″ × 14″ (28cm × 36cm). Open Box M is located in Cody, Wyoming, and can be reached at (800) 473-8098.

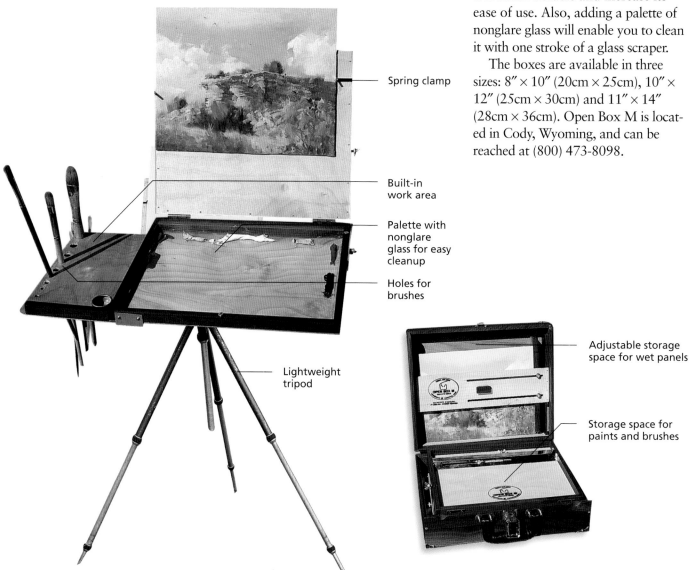

Spring clamp

Built-in work area

Palette with nonglare glass for easy cleanup

Holes for brushes

Lightweight tripod

Adjustable storage space for wet panels

Storage space for paints and brushes

PAINTING ON LOCATION

When painting oils on location, it is essential to have storage capacity for the wet paintings. One of the simplest solutions is to store your wet paintings in *dryboxes*, or wet canvas carriers. These dryboxes are easy to make and are an important part of the logistics of working in the field. I cut my notches ⅜″ (10mm) wide, allowing for two back-to-back ⅛″ (3mm) panels or one ¼″ (6mm) panel. The narrow boxes are designed for day use and are cut with three notches with the capacity of six ⅛″ (3mm) panels or three ¼″ (6mm) panels. The larger box, which holds 12″ × 16″ (30cm × 41cm) panels, is for longer painting trips, while the plastic drybox works well for smaller panels. I suggest taking an 8″ × 10″ (20cm × 25cm) panel into the store to select an appropriately sized storage container. Note, however, that these plastic boxes have a tendency to crack with a lot of hard use. The container at right has a storage capacity of forty-four wet 8″ × 10″ (20cm × 25cm) panels in the back-to-back mode, or twenty-two slots for single panels.

Painting on stretched canvas is another option. I have always loved the flexibility and give of stretched canvas. However, they take up a greater volume of space than panels. On a long trip, that can be a significant factor. When working on stretched canvas in the field, M-clips prove useful for storage and transport. These clips are designed to hold two wet canvases together, face-to-face, with air space between. These days, I only work on stretched canvas when I am close to home. When traveling, the simpler logistics of panels is hard to beat.

Dryboxes

Ready to Go

I came upon this subject while driving through Hayden Valley in late afternoon. The wind was so strong that I set up my Pochade box in the passenger seat of my van and went to work. It was a beat-the-clock scenario as the sun was rapidly setting.

Sometimes working quickly can lead to mistakes or misjudgments that can easily scuttle a painting. However, a successful effort under these conditions produces a piece where the passionate response is evident on the face of the work. It's a quality that can be difficult to find in most studio paintings. Whether traveling or at home, keep a Pochade box packed and ready to go at a moment's notice.

HAYDEN VALLEY, YELLOWSTONE NATIONAL PARK
Oil on panel
8″ × 10″ (20cm × 25cm)
Private collection of Kathleen and Alan Lascelles

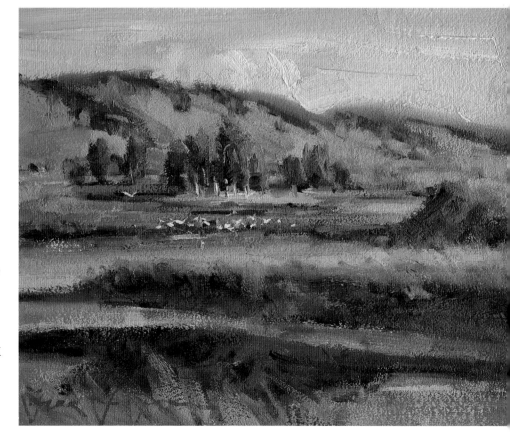

Logistics for Large-Scale Oil Paintings

From a plein air standpoint, I refer to large-scale work as 12″ × 16″ (30cm × 41cm) or greater. Granted that isn't very large, but when trying to keep up with changing light, it's large enough. When oil painting, there are two setups I like for large-scale work. One is a half-portable solution (an adapted Yarka Russian easel), and the other is my most comfortable edition (a French easel).

YARKA RUSSIAN EASEL, ADAPTED

This setup is useful when there is hiking involved and you want to work on a scale larger than a Pochade box can accommodate. The Yarka Russian easel is available in three sizes: 9″ × 12″ (23cm × 30cm), 12″ × 16″ (30cm × 41cm) and 16″ × 20″ (41cm × 51cm).

To adapt my Yarka Russian easel, I made a number of changes that you can also make. ① The first thing you can change is the system of securing the canvas. Replace it with a narrow piece of wood, cut with a ⅜″ (10mm) notch for a panel, measured so it fits inside the easel when closed. Drill it with two holes, one on each end, then drill a series of holes in the easel itself. Be certain to drill the holes carefully (at 90° to the top of the easel) so that everything fits snugly. Next, color code the holes for ease of use, and set the crosspiece at any point by securing it with two bolts ³⁄₁₆″ (5mm) wide. As an option, consider using a wing nut on one of the bolts behind the easel to hold it more firmly.) The result is a system that will hold the canvas securely, and it takes only moments to set up.

There are a number of other optional additions. ② You can add a piece of wood on the top for an umbrella mount. (Note how the piece is held on by two wing nuts under the top.) The piece of wood should stick out a few inches over the top, just enough for the umbrella C-clamp to grasp. ③ Add a palette of nonglare glass glued onto a piece of ¼″ (6mm) mahogany plywood

with silicone glue. ④ Secure a brush holder to the left side of the easel with two bolts and wing nuts. (This piece fits into an outside pouch of my daypack.) ⑤ For a brush cleaner, adapt a can (I used a Spam can), fitting it with a piece of screen and cutting it with a low profile so that it fits into your easel when it is closed. Two bolts are permanently mounted in the can. Drill corresponding holes on the side of the easel, allowing the can to slide in firmly. ⑥ Mount a piece of wood to the center of the easel back (in the photograph it is directly under the crosspiece). This will hold the palette securely when the

easel is folded. ⑦ Remove some of the hardware that the easel came with, including the metal hardware used to support the canvas. Also remove the carrying strap and add a handle on the right top.

All of these changes can be made in one afternoon. The result is an easel that is easy and fun to use. It has a large enough palette to accommodate oil paintings up to 20″ × 24″ (51cm × 61cm). And most important, it is easily carried in a daypack. (Note: When using it in the field, I also bring along a narrow drybox that was specifically designed for that purpose.)

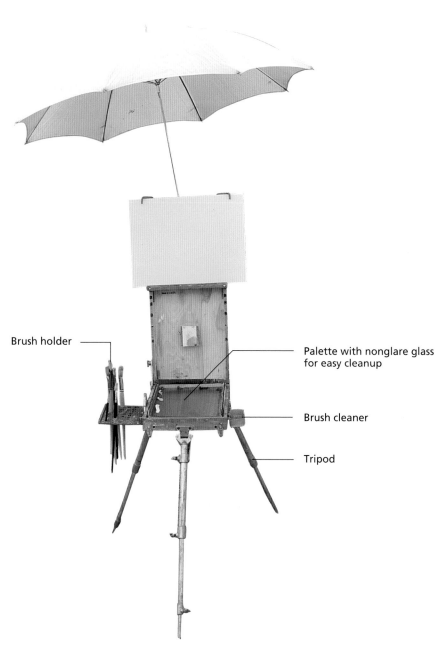

Brush holder

Palette with nonglare glass for easy cleanup

Brush cleaner

Tripod

With the Help of My Easel ...

This oil was painted while field-testing my modified Russian easel. The setup was designed as daypack logistics. It's handy to have a setup that can be carried onto an airplane or can also be used while hiking. There was no sense of sacrifice in switching to this lighter and more portable gear.

VILLACITO
Oil on panel
12″ × 16″ (30cm × 41cm)

SETTING UP YOUR ADAPTED YARKA RUSSIAN EASEL

Many of the materials needed for setting up, including the nuts and bolts and the wood piece that holds the canvas, are stored inside the easel under the palette. Since the palette often contains wet paints from a previous painting session, lift the palette out of the way while setting up. Use a small bungee cord to temporarily raise the palette by hooking the cord to a hole drilled in the plywood palette and attach it to the top of the easel. When you are finished, simply remove the cord, lower the palette and begin painting.

Umbrella mount

Color-coded holes

Crosspiece secured with bolts (wing nuts are optional)

Wing nut

Nonglare glass palette

Brush cleaner

Brush holder

FRENCH EASEL/EASEL PAL

My most comfortable oil painting set-up by far is the French easel with an Easel Pal palette resting on the open drawer. I use my white clip-on umbrella when needed and attach it in the same way as on the half-size easel.

The Easel Pal is a great organizer that makes working with the easel a lot easier. The two sides close and latch, protecting the wet paint on the palette's surface. When open, the two sides provide space for brushes, thinner, rags and so on. You can customize yours by adding a palette of nonglare glass and also a wet brush holder.

They are available in two sizes, 12″ × 16″ (30cm × 41cm) and 16″ × 20″ (41cm × 51cm). Easel Pal is based in Rio Rancho, New Mexico, at (505) 892-7752.

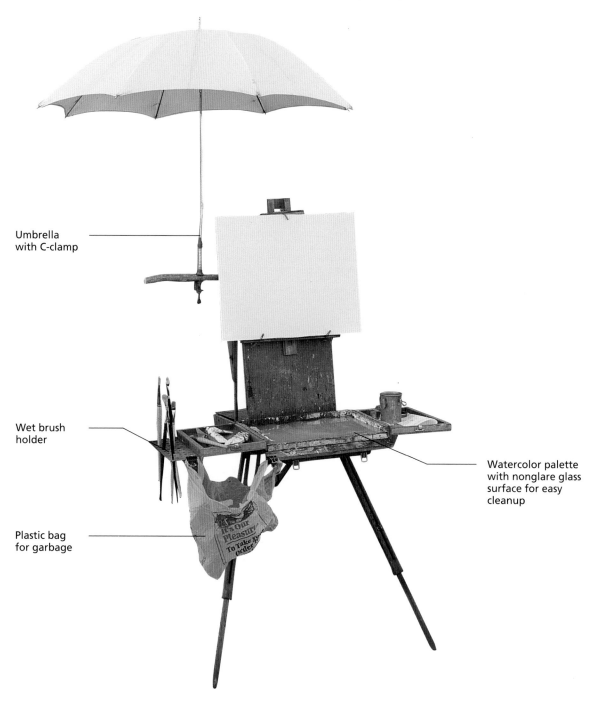

Umbrella with C-clamp

Wet brush holder

Plastic bag for garbage

Watercolor palette with nonglare glass surface for easy cleanup

This subject is only a mile or two from my home. Since there was no premium for economizing on weight or volume, I took the easiest approach: I used my French easel/Easel Pal setup, my most comfortable oil painting setup. Remember: The less time spent struggling with equipment, the easier it is to maintain concentration.

BOUQUET LANE
NAMBE, NEW MEXICO
Oil on canvas
12″ × 16″ (30cm × 41cm)

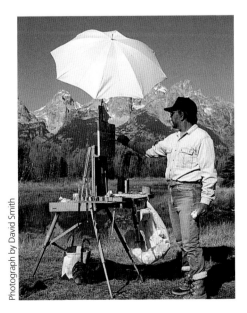

Photograph by David Smith

Plein Air Painting
The photograph of this French easel/Easel Pal setup was taken in Grand Teton National Park. It's not the most portable setup. In fact, it can be pretty heavy to carry for any distance. But it offers maximum comfort and ease of use. For both large-scale work as well as maximum convenience, this is my setup of choice.

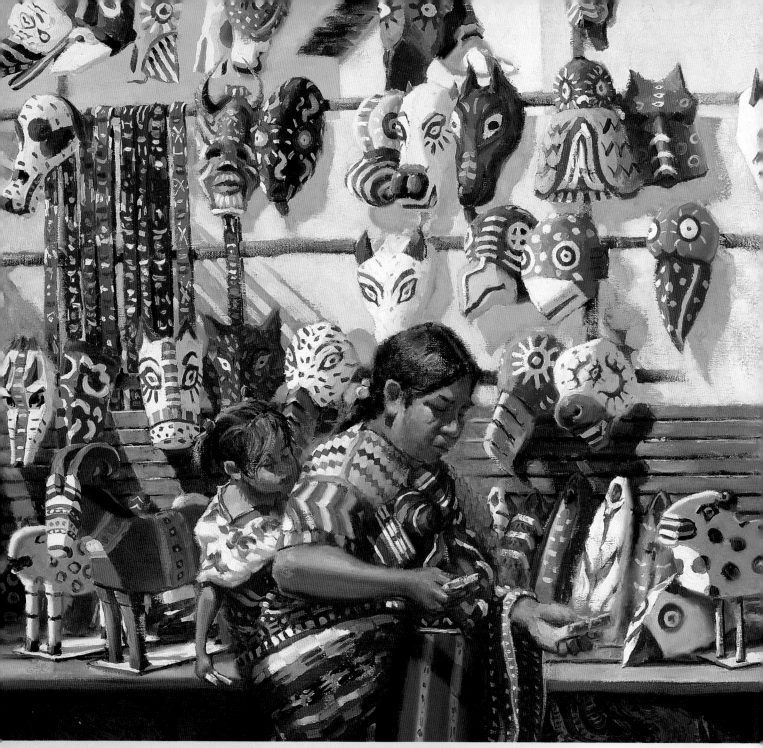

The Indian markets of Guatemala are the most colorful spectacles I have ever seen.
Indians selling their produce, textiles and various handicrafts draw busloads of tourists
who come to marvel over the extraordinary Sunday scene.

 Watermelon Mama *was conceived in response to the overwhelming dose of color that
is Guatemala. It expresses that feeling—a no-holds-barred, full-speed-ahead approach to
using color. No excess was too great! I wanted a painting that was like a color bomb
going off inside the frame; in other words, my experience of being in Guatemala.*

two MAKING THE MOST OF YOUR COLORS

Using color is one of the more subtle and difficult aspects of plein air painting, from mixing realistic colors to selecting the right values. Matching the colors of nature is the bottom line for a plein air painter, and a good place to start is with an understanding of the various aspects of color.

WATERMELON MAMA,
CHICHICASTENANGO,
GUATEMALA
Oil on canvas
30" × 40" (76cm × 102cm)
Private collection

Color

There are three separate and distinct aspects of color: hue, value and saturation. Imagine trying to describe the color of your new car over the telephone. Calling it red is hardly sufficient, for there's a whole universe of reds out there. It is easy to give an accurate verbal description of a particular color if you understand three aspects. *Hue* refers to what color it is (e.g. red, blue, green). *Value* refers to how light or dark the color is, irrespective of the hue. And *saturation* is the degree of purity or neutrality of the color.

Each hue has its own unique value and saturation. For example, take values. The range of values is different for each color. Pure yellow doesn't go very dark, so its range of values is more high key, remaining in the light range of the *value scale*. For pure Cadmium Red Light, its darkest value is in the middle value range. Ultramarine Blue is the darkest pigment and thus has the widest range of values, from a low key (dark) to a high key (its lightest value).

A *saturation scale* can also be made for each color. This scale starts at one end with the pure color and ends with a color so neutral that it can barely be identified with the hue that started the scale. The degree of saturation describes the relative purity or neutrality of any given color; in other words, its location on a saturation scale. An understanding of these three separate and distinct aspects is a necessary starting point for a meaningful discussion of color.

Color temperature refers to the relative warmth or coolness of a color, and it is one of our most useful observational tools. This concept provides a way of seeing and describing the most subtle color modulations. Temperature is one of the key relationships to look for when comparing the colors of the

Value Scale

High Value ← → Low Value

Cadmium Red Light

Gamboge Hue

Ultramarine Blue

A value scale illustrates the lightness or darkness of a color. It starts with the tint, or the color closest to white, at one end (low value) and ends with the darkest value possible for the given color at the other (high value). (This value differs from color to color. The darkest value of yellow is lighter than the darkest value of blue.)

various elements of a painting to each other. The warmth or coolness of a color mixture can be easily modified. For example, a green mixture is easily warmed by adding more yellow or orange and cooled by adding more blue.

Some temperature relationships are absolute: blue is always cooler than orange; Cadmium Red Light is always warmer than Quinacridone Red. Think of color temperature as another way of seeing and understanding color, as a way of fine-tuning your observations.

Saturation Scale

High Saturation ← → **Low Saturation**

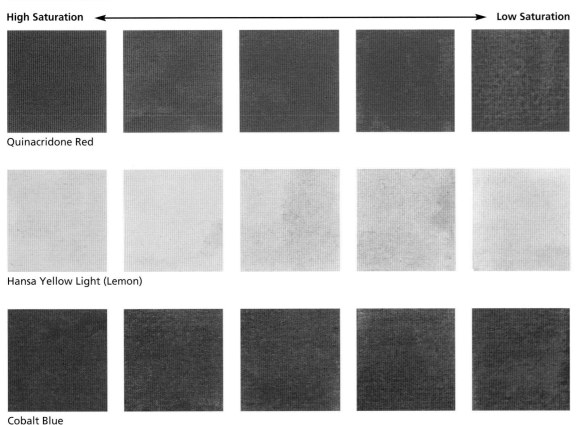

Quinacridone Red

Hansa Yellow Light (Lemon)

Cobalt Blue

A saturation scale illustrates the relative purity or neutrality of a given hue. It starts at one end with the pure color (high saturation), and it ends with a color so neutral (low saturation) that it can barely be identified with the same hue that started the scale.

Temperature Scale

Warm Temperature ← → **Cool Temperature**

Accurately seeing and understanding the color temperature relationships between the various elements of a painting is an important step in translating the color harmonies of nature onto your painting surface.

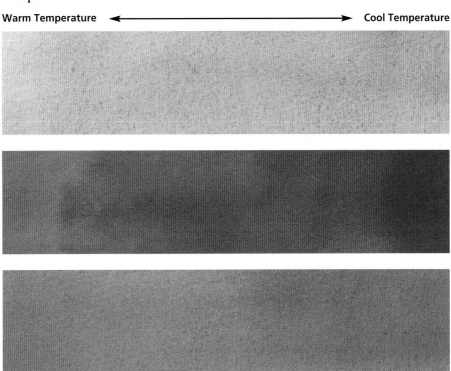

Mixing the Colors of Nature

Matching your color mixtures to the colors of nature is the bottom line for plein air painters. It is primarily a process of neutralizing more highly saturated pigments. Although mixing colors may seem complex and confusing, it can be simplified. There is one concept to remember: *red + yellow + blue = neutral gray.* This is much more than a formula for making gray. It has profound implications on every color mixture you will ever make.

One of the first things you probably learned about mixing the colors of nature is that pure colors on your palette don't accurately represent the colors of nature. For example, pure blue from a tube doesn't represent the sky in a convincing way. It looks harsh and unnatural. Likewise, using pure Viridian (or any other green straight from the tube) doesn't make for a realistic tree. Remember, you want to paint the effects of light, not things. A blue sky has warmth, and that degree of warmth differentiates one location from another, as well as time of day and season of the year. Just the same, a tree is not only green. It contains the full spectrum of light, green predominating.

What to do? Try this. Plug green into the formula. Green (or yellow + blue) + red = neutral gray. The pure tube green needs a little red to tame it down (see above). Try the same idea when painting a blue sky. Ultramarine Blue is too raw when used straight from the tube. Try it in the equation: blue + yellow + red = neutral gray. What it needs is a touch of yellow and red (or orange) to make the sky more lifelike.

When you begin to see the light on the tree and not the tree itself, you are beginning to see the influence of red within the green of the tree; you are now weighing the red, yellow and blue of your mixture. It's not an exaggeration to say that all mixtures are various combinations of red, yellow and blue.

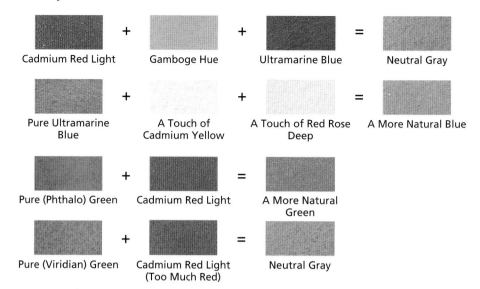

Cadmium Red Light + Gamboge Hue + Ultramarine Blue = Neutral Gray

Pure Ultramarine Blue + A Touch of Cadmium Yellow + A Touch of Red Rose Deep = A More Natural Blue

Pure (Phthalo) Green + Cadmium Red Light = A More Natural Green

Pure (Viridian) Green + Cadmium Red Light (Too Much Red) = Neutral Gray

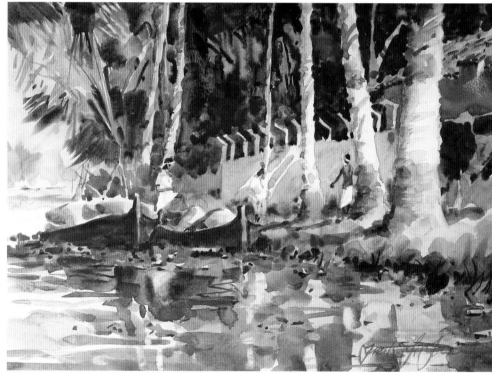

The Question of Green
Green can be a difficult color to use effectively. In a painting with a strong, dominant color, it is important to engage the entire palette of colors in all the mixtures of the painting. Note the color variety in the various mixed greens of this watercolor. For example, in the area above the fence, there are Ultramarine and Cobalt Blues, Cadmium Red Light, Gamboge Hue and Hansa Yellow Light. (These colors are mixed into the greens as well as retaining some color identity of their own.)

THE MALABAR COAST
Watercolor on Waterford 90-lb. (190gsm) hot-press paper
11" × 15" (28cm × 38cm)
Private collection of Maxine and Eric Michaels

Color Wheel

Think of a color wheel as an abstract representation of color. It's like a rainbow that has been connected (end to end) to form a circle. The practical application comes by locating the pigments you use on the wheel, which helps in understanding their relationships to one another.

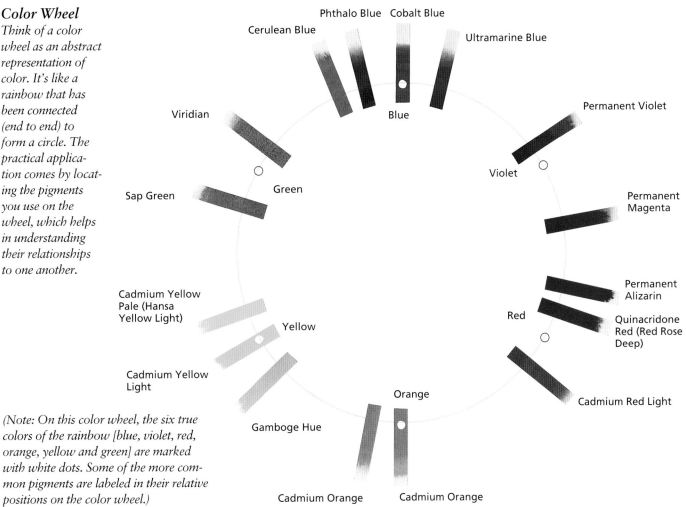

Phthalo Blue Cobalt Blue
Cerulean Blue
Ultramarine Blue
Blue
Viridian
Permanent Violet
Green
Violet
Sap Green
Permanent Magenta
Permanent Alizarin
Red
Quinacridone Red (Red Rose Deep)
Cadmium Yellow Pale (Hansa Yellow Light)
Yellow
Cadmium Yellow Light
Cadmium Red Light
Orange
Gamboge Hue
Cadmium Orange
Cadmium Orange

(Note: On this color wheel, the six true colors of the rainbow [blue, violet, red, orange, yellow and green] are marked with white dots. Some of the more common pigments are labeled in their relative positions on the color wheel.)

The next logical question is which red plus which yellow plus which blue should be used? To answer that, we need to understand the nature of our pigments. A good place to start is by locating them on a color wheel, or a graphic representation of the refraction of light, where the relative position of each pigment defines its characteristics.

Let's take a look at the blue segment of the color wheel. Cobalt Blue is a true blue, indicated by its position on the wheel. Ultramarine Blue is located more toward red, while Phthalo Blue is closer to yellow. Using Ultramarine Blue is like adding a tiny amount of red to a mixture along with the blue, and using

Phthalo Blue is like adding a tiny bit of yellow. When Ultramarine Blue is used to mix green, that tiny amount of red will have a slightly neutralizing effect. Phthalo Blue, which doesn't have any red, will produce a more saturated green when used in a mixture with the same yellow. Likewise, using Phthalo Blue in a violet mixture is like introducing a tiny bit of yellow, a neutralizer. Expect a totally different shade of violet when using Phthalo Blue as opposed to Ultramarine Blue, when mixing with the same red.

Understanding where pigments fall on the color wheel gives insight into how each will react in color mixtures

HELPFUL HINT

A good way to get acquainted with your paints is by mixing various combinations on scrap paper, trying to vary the value and saturation of each color. So go ahead and start mixing, but more importantly, have fun!

Choosing the Colors of Your Palette

When you paint on location, you are painting the effects of light. When you see a rainbow, that is nature's palette. The first thing you'll notice about the colors of the rainbow is the absence of *neutral colors*, including the earth tones. They are not really absent from the color spectrum but, rather, they are contained within it. The earth tones and other neutral hues are really red, yellow and blue (*primary colors*) working overtime. Taking a cue from nature, you can eliminate the neutral colors from your palette and mix them from the primaries. Your pigments will then be mimicking light while creating a more believable light effect in the process.

In choosing a palette, there's a compelling argument for simplicity. The one thing we know for sure is that we need three colors to paint light: a red, a yellow and a blue. Using fewer colors has the benefit of getting more service out of each. Your reds, yellows and blues will literally be everywhere in the painting. The colors will harmonize more fully, adding greater color unity to your work. This degree of interrelatedness is hard to achieve when using a palette of many different pigments.

Another benefit of a simple palette is in the color mixtures themselves. Although mixing the more neutral hues may be inconvenient (it takes more time to mix your own colors), it is possible to produce mixtures that are accurate in value and saturation, while subtly retaining the color identities of the pigments that produced them. The different color identities within the various mixtures of a painting will energize the work. Ironically, by reducing the number of pigments used, you often end up with more colorful paintings.

Perhaps the greatest benefit of a simple palette is in changing the thought process of color mixing. When matching your colors to the colors of nature, place more emphasis on the light spectrum and less emphasis on individual pigments. For example, learn to reach for a warm red rather than Cadmium Red Light; a cool yellow instead of Cadmium Yellow Pale. In time you will actually begin to see specific reds, yellows and blues within the more neutral colors. Painting light is different than painting things. It requires expanded visual awareness, and it often brings changes to the palette, usually toward greater simplicity.

You can also add to your basic groups of colors. In the summer, for example, you can add Viridian. Or on other occasions, you can substitute different pigments for the basic six, such as Phthalo Blue or Cerulean Blue for Cobalt Blue, or Permanent Alizarin for Quinacridone Red. I sometimes use Aureolin (Cobalt Yellow) as my sole yellow, replacing both the warm and

Basic Color Palette

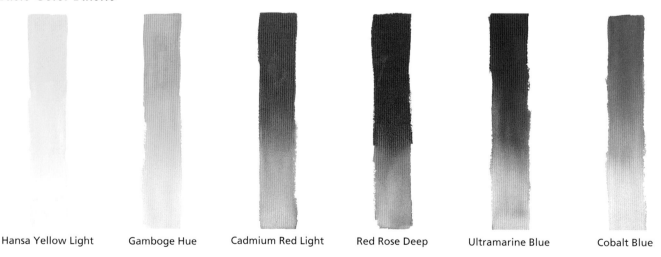

| Hansa Yellow Light | Gamboge Hue | Cadmium Red Light | Red Rose Deep | Ultramarine Blue | Cobalt Blue |

I use the same essential palette in both watercolor and oil with one exception. In watercolor, I substitute more transparent yellows for the Cadmiums, because I prefer the more transparent pigments.

cool versions (particularly in watercolor). These decisions are intuitive, based on subjective feelings about what you are painting, as well as on your observations of the light itself.

COLOR MIXING AND EARTH TONES

Mixing colors that are accurate in regards to value and temperature, while retaining the color identities of the pigments used to produce the mixture, is a skill within a skill. The painting at right is a good illustration of this idea.

As with *Santa Catalina*, color can be mixed directly on the painting surface. That requires accuracy and value control. The premium in not overmixing your colors is a freshness of handling. Correcting mistakes lessens the effectiveness. The danger is that by the time you get it right, the passage will have been stroked into oblivion. Color that was once fresh will have been blended into a flat, neutral tone.

Earth colors, such as Yellow Ochre, Raw Sienna, Burnt Sienna and Burnt Umber, are easy to mix and use. They are basically more neutral versions of the pure colors, and they can be used to neutralize the more highly saturated pigments.

The main advantage to eliminating tubes of earth colors from the palette is in more fully integrating your reds, yellows and blues into all the mixtures of your painting. An added bonus is energizing the painting with more lively color passages. In all three mixed versions of the earth colors (below), you can see the color identities of the pigments that produced the mixture. These different color vibrations add interest to a passage while promoting stronger color unity.

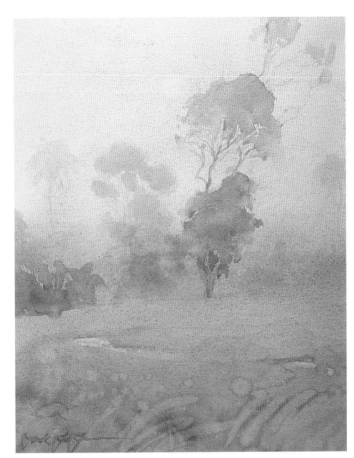

SANTA CATALINA
Watercolor on Arches 140-lb. (300gsm) cold-press paper 22″ × 15″ (56cm × 38cm)

Mixing Earth Tones

Here, a significant amount of color mixing was done directly on the paper. The goal was to capture a true atmospheric effect while at the same time getting more color into the painting. The essence of the light effects is the limited value range.

Mixing Earth Tones

Pure Yellow Ochre

Mixture of Gamboge Hue, Red Rose Deep and Ultramarine Blue

Pure Burnt Sienna

Mixture of Gamboge Hue, Cadmium Red Light and Ultramarine Blue

Pure Burnt Umber and Titanium White

Mixture of Cadmium Yellow Pale, Quinacridone Red, Ultramarine Blue and Titanium White

Mixing earth colors requires all three primaries. Note how closely the pure earth colors straight from the tube (left column) match the mixed colors (right column).

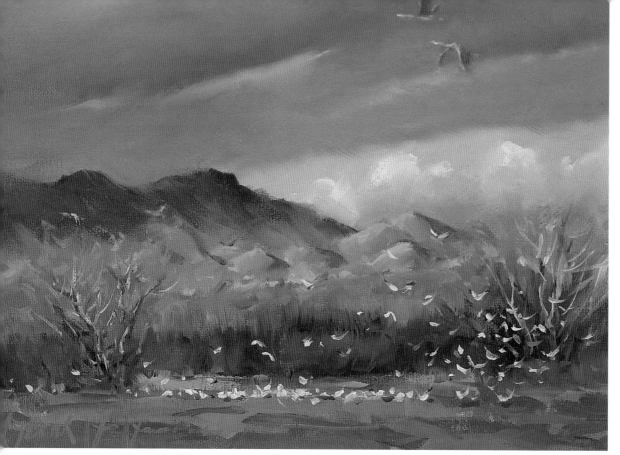

Whenever you are painting a subject with a high degree of color saturation, it is impera-
tive to get clean color down on the white ground as you block in passages. The pure white
of the canvas will give the color an extra jolt, particularly in the transparent and semi-
transparent range. Here, some of the original strokes of pure color (slightly thinned with
mineral spirits) show through in the finished product. As a watercolorist, I highly value
the white ground of an oil painting for the brilliance it can bring to the finished painting.

BOSQUE DEL APACHE
Oil on canvas
9″ × 12″ (23cm × 30cm)
Private collection of Maggi and Bob Kitts

FINAL CONSIDERATIONS WHEN SELECTING PIGMENTS

When selecting pigments, the attrac-
tiveness of colors is but only one con-
sideration, and arguably not even the
most important. The actual pigment in
the tube is really the most important
consideration. The first thing I look for
is the fine print on the tube that identi-
fies the pigment. If it's not listed, I con-
clude that the manufacturer is not
serious in supplying artists with the
information or materials they need.
The description of pigments is often
coded into standardized color index
names, such as PY 35 (Cadmium Yel-
low Light). There are a number of
books available in art supply stores
that identify the pigments by these
numbers as well as provide descrip-
tions of their properties.

Besides varying degrees of perma-
nence (see page 12), pigments' *body*

qualities also vary. Some pigments are
transparent, or can be seen through,
some are *semitransparent*, and yet oth-
ers are *opaque*, or cannot be seen
through. If a pigment is transparent in
watercolor, then it is also transparent
in oil painting, for it is the same pig-
ment in both. There tends to be some
misunderstanding concerning this.
Some people refer to watercolor as if
all the colors are transparent, while all
oil paints are not. Not so. The trans-
parency of oil paint is one reason I give
my white ground the respect it deserves
(see page 85).

The quality of transparency or
opacity is innate to each pigment. Ul-
tramarine Blue is transparent in both
oil and watercolor. For example, the oil
paint swatch (at far right) is Ultrama-
rine Blue mixed with Titanium White
for the tint. (Note that the pencil line is
blocked by the opaque white.) In the

next swatch, Ultramarine Blue is
thinned with mineral spirits for the tint.
It is still fairly opaque in the midrange
even though it has been thinned with
mineral spirits rather than mixed with
Titanium White. (Note the pencil line
running through the middle, illustrating
the transparent quality of the pigment.
Even opaque pigments become semi-
transparent or transparent when
thinned enough.) If white paint was
added to the watercolors at right, the
effect would be similar to the examples
in oil. Note, however, that white paint
is typically not used in transparent wa-
tercolor painting.

These are considerations that deal
with the craft of painting rather than
the more subjective realm of seeing col-
or. Getting to know the qualities of the
individual pigments is important to get-
ting the most out of your palette.

Transparency: Watercolor vs. Oil

Pigments that are transparent in watercolor are also transparent in oil, as illustrated below. The transparency or opacity of an individual pigment is an inherent trait and not a function of the medium.

Watercolor **Oil**

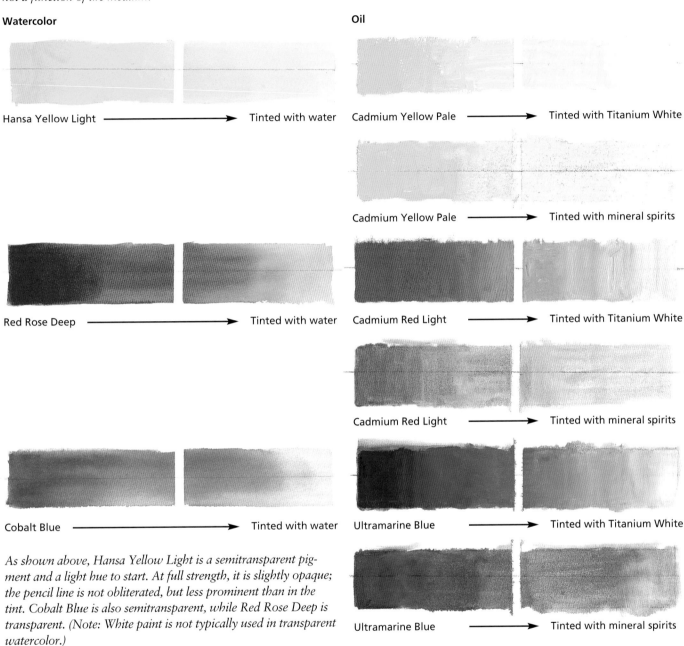

Hansa Yellow Light ⟶ Tinted with water

Cadmium Yellow Pale ⟶ Tinted with Titanium White

Cadmium Yellow Pale ⟶ Tinted with mineral spirits

Red Rose Deep ⟶ Tinted with water

Cadmium Red Light ⟶ Tinted with Titanium White

Cadmium Red Light ⟶ Tinted with mineral spirits

Cobalt Blue ⟶ Tinted with water

Ultramarine Blue ⟶ Tinted with Titanium White

Ultramarine Blue ⟶ Tinted with mineral spirits

As shown above, Hansa Yellow Light is a semitransparent pigment and a light hue to start. At full strength, it is slightly opaque; the pencil line is not obliterated, but less prominent than in the tint. Cobalt Blue is also semitransparent, while Red Rose Deep is transparent. (Note: White paint is not typically used in transparent watercolor.)

For each of the oil colors above, there are two strips. One strip illustrates the color when it is thinned with mineral spirits. The other strip illustrates the color lightened with Titanium White. (Note: The addition of white paint adds opacity to each color, while paint that is thinned with mineral spirits remains more transparent. Even opaque colors, such as the Cadmiums, are transparent when thinned enough.)

THE NATURE OF COLOR

Adding white paint to a color not only lightens it, but also changes its nature in a very subtle way. Titanium White is used with oils to lighten colors and create tints. For transparent watercolors, however, colors are lightened by adding clean water. The resulting tints are pure expressions of those colors.

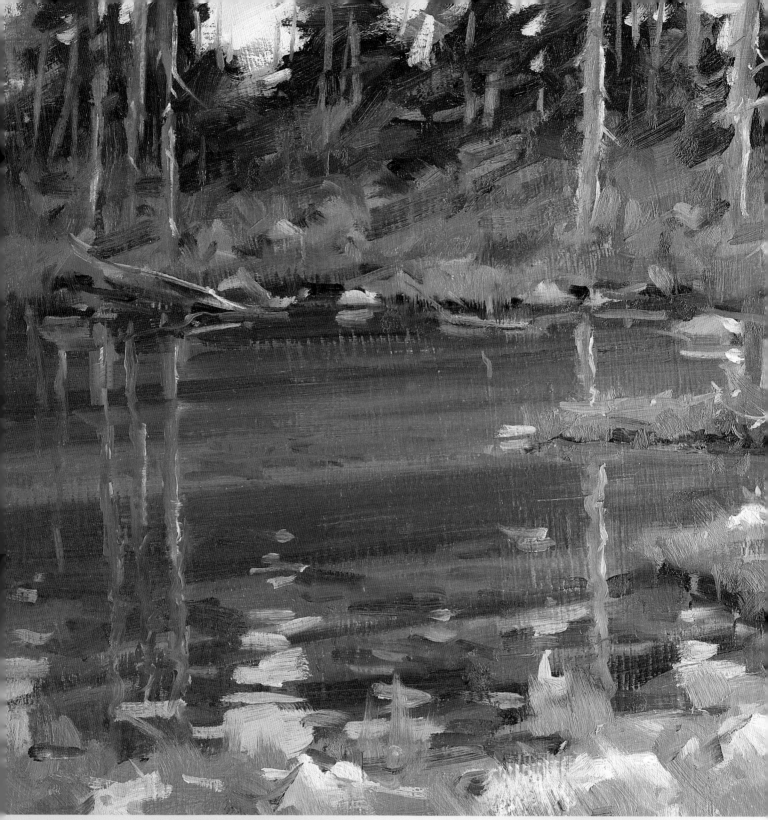

Mirror Lake *was painted in Wyoming's Medicine Bow National Forest. I had noticed the day before that this was a morning spot, and I arrived early enough to be painting when the sun broke over the mountains. First light was a moment of serenity and great beauty. To be a painter at such times is a privilege. All the hard work, years of experience and painful failures suddenly have purpose: to learn the language of painting for this one moment. Every day is an opportunity for such an experience. Art is a life-affirming activity. Plein air painting will open your eyes to the beauty that is around you. Producing better art is a pleasant by-product.*

three PLEIN AIR PAINTING

Painting from life is the great teacher. This is not my idea: it's the wisdom of the ages handed down to us. Nature presents herself in an infinite variety of colors, values and textures. The ability to organize this wonderful chaos is a learned skill and is fundamental to any real goal of self-expression. We paint from life in order to learn how to see. Learning to see is truly a life-long process. Visual perceptions mature and deepen over time, unfolding like petals of a flower. There is no greater thrill in painting than when you begin to clearly see things that previously went unnoticed. The more you are looking for, the more you see, and the more you see what you have been missing all along.

Your painting is like a document stating how well you see and understand the world around you. Reduce the confusion and a major barrier to good painting is removed. Clearing up clouds of visual confusion also creates a positive forward momentum in the work. The result of plein air painting is a greater appreciation of the world around you, as well as better art.

This chapter, devoted to plein air painting, has evolved over years of working with students. My goal in teaching, as in painting, is to simplify difficult subject matter. The best strategy is to approach nature with humility: like a child who is seeing something for the first time.

MIRROR LAKE
Oil on panel
12″ × 16″ (30cm × 41cm)

The Three S's of Plein Air Painting

Simply stated, the three S's of plein air painting are *see* it, *simplify* it and *state* it.

SEE IT

In order to succeed in plein air painting, you must see with uncommon clarity. Your observations must be of high quality and suited to the task at hand. A finished painting is greater than the sum of its parts. You must see beyond the beautiful elements, all so distractingly lovely and seductive, and penetrate to the essence of the subject. The color and value relationships between the elements form the real foundation of your work. At this level of thought, style is of no consequence. Detail may or may not be added, but no amount of rendering is sufficient enough to save a work that has misjudged the fundamental relationships of color and value.

As an artist, you translate the three-dimensional world onto a two-dimensional canvas or paper. The idea of translation is the perfect metaphor. We see the objects of a landscape as existing in space. A tree is in front of a mountain. In two dimensions, however, an edge is formed where the tree and mountain touch. Seeing it in two dimensions changes everything.

The first thing every artist should learn is the usefulness of squinting down the subject. Close your eyes a bit (about halfway) and look at the subject. Squinting it down helps to filter out nonessential detail. Imagine the scene as if it were a jigsaw puzzle, with the various elements of the landscape as pieces. The tree is a piece, the mountain is a piece, and so on. Viewing the landscape in this manner will help you see the relationships between the pieces, which is the heart and soul of what we are really after. Getting these relationships accurate is what will give your painting that atmospheric or correct feeling.

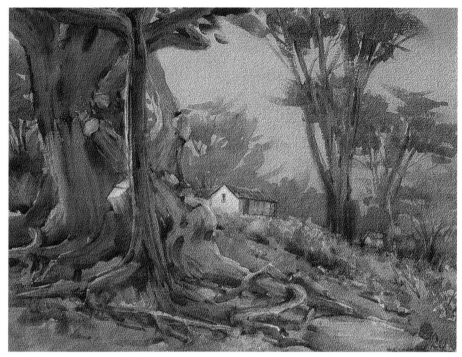

Plein Air Painting
There is often a point in a painting when the instinct to play it safe arises. Getting cold feet about an observation is natural, particularly if what you see seems unconventional. Playing it safe in such a situation is, in its own way, a mistake. Even if the passage in question turns out to be wrong, at least it was honest. Some mistakes are better than others and are like badges of honor on the road to fearlessness in painting. Don't be afraid to make mistakes. Just go for the higher quality ones.

THE OLD CYPRESS TREE OF CARMEL
Watercolor on Arches 140-lb. (300gsm) cold-press paper
22" × 30" (56cm × 76cm)

SEEING BY COMPARISON

It is difficult to judge the exact color and value of a given element of a landscape out of context. It is easier to see, understand and judge by comparing one element to another. Squint it down and ask yourself several questions. Is the mountain lighter or darker than the tree? Is the light on the tree lighter or darker than the sky? Which tree is greener, which bluer? Cross-referencing your observations will help you place elements in their proper pecking order, for the relationships of color, value and edges are essential to achieving particular effects. Look for relationships instead of things. When you see a tree as its color and value in relation to other colors and values, rather than as a separate and distinct object, then you are thinking like an artist. Not only will it energize your work, but your tree will look more like a tree!

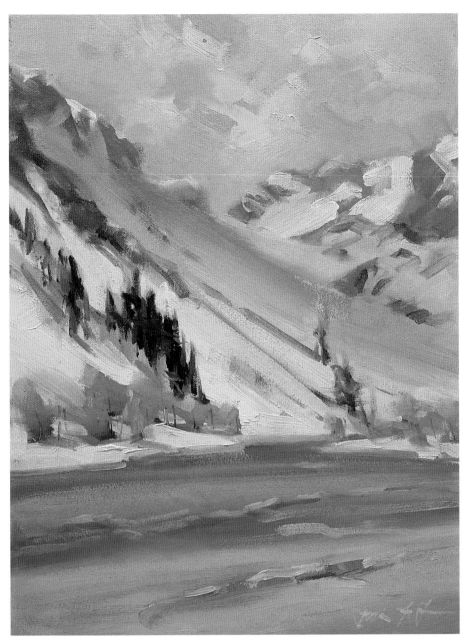

The heart and soul of this piece is in the subtle color, value and temperature relationships in the lights. To judge these colors and values out of context, it is easier to use the concept of seeing by comparison. Properly aligning these relationships and simplifying them is the challenge.

Remember: Creating accurate relationships will give a painting its feeling of light and atmosphere. Through observation, you should ① first establish that the value of the clouds (in sunlight) is a step darker than the snow (also in sunlight). When squinted down, there should be no confusion about these two values. ② The snow on the mountains and to the right and left of the dark pine trees also has varying color temperatures. Compare each piece of snow to its neighbors and adjust accordingly. ③ Use the same process to see and paint the exposed rocks of the mountain, comparing one area to another and determining the darkest, lightest, warmest and so on. ④ Likewise, compare the color and value of the shadow on the mountain with the frozen ice. ⑤ The value range of the painting is narrow: the only real dark is in the diagonal stand of pines in the middle left. These should be added early to help you see your values. It is easier to judge the middle-value shadow (on the side of the mountain) when you have both a dark and a light present.

SPRING THAW, CONVICT LAKE
Oil on panel
16" × 12" (41cm × 30cm)
Private collection of Maureen Meade

SEE AS A CHILD

To see like a child, utterly guileless and without any preconceived ideas or learned solutions, is easier said than done! As an adult, this is a state that you can only approach. To even come close, it is more important to unlearn some of the things you "know" than it is to add to your body of knowledge.

Art is full of platitudes and truisms that you, the artist, pick up along the way. These formulas provide the comfort of certainty, but in the end they aren't always helpful. The best strategy is to clean house of all preconceived notions and start from scratch. Just trust what you see. This is not easy, especially when a perception goes against prevailing wisdom. Moving from a place of certainty to one that leaves you constantly hanging over the edge is never easy, but it is the right place to be.

SIMPLIFY IT

The goal of simplifying is to keep the essential and eliminate the unnecessary. Who can argue with that? And yet I often see paintings full of detail within collapsed value structures. It reminds me of a quote by the poet Stephane Mallarme: "It is the job of poetry to clean up our word-clogged reality by creating silences around things." And so it is with painting. Nature's great variety can be intimidating. It takes a high degree of understanding to effectively simplify something so complex.

A good way to start is by organizing the elements of your scene with preliminary drawings and sketches. Close observation and drawing is the best way to get to know your subject. A few minutes of drawing will often turn a mediocre subject (first impression) into an exciting one.

Drawing and Preliminary Sketches

Unless a dramatic change of light is imminent, I recommend doing some preliminary work in your sketchbook. A sketchbook is like a tool for visually thinking out loud, organizing the chaos of nature into a simple and effective plan. The type of work depends on many factors, such as the nature of the subject, the degree of complexity, as well as the medium with which you'll be working. When working in oil, I often spend less time on the preliminary drawing as the medium is good at coaxing a drawing out of the developing image. Watercolor, on the other hand, is less forgiving. Wholesale changes are more difficult to accomplish cleanly. When planning a watercolor of a complex subject, a little more drawing in the preliminary stages increases the chances for success.

There are two different types of drawings you can do on location. The first, a *modified line drawing*, is purely for the purpose of getting to know your subject. These drawings are especially helpful when there are figures or man-made objects involved, or subjects you're unfamiliar with. Complex foreshortening and odd vantage points are both good reasons for taking an extra minute to try to understand exactly what you are looking at. (I frequently bypass this type of drawing, however, and go straight to the next type. See pages 50 and 51.)

Another type of drawing is the *three-value thumbnail sketch*. Here you will make decisions and not just report facts. The three-value sketch is invaluable to simplifying value patterns. Because Nature rarely presents herself in three-value landscapes, it is up to you to combine and organize the various elements of the composition into large, clear shapes consisting of three values (light, middle and dark), creating a strong, simple design. For example, a middle-value shape may include a tree, a ground shadow and perhaps part of a building. A color change, while holding its value, is enough to provide separation between the different elements. Holding the integrity of your large shapes is what the value sketch is all about.

This is the time to organize the material into something that is understandable at a glance. If there are no clear shapes or value separations, uncertainty and confusion can easily result in overworked paintings. Starting on the right foot as well as staying on track throughout the process are but two of the benefits from a few minutes of preliminary work. It's like a vaccination against a poor outcome.

The Scene
Although the scene is not overly complex, there are enough interesting elements to make a worthwhile sketch.

Modified Line Drawing
This drawing is helpful in understanding some of the information, as well as clarifying what will be stressed and simplified.

Three-Value Thumbnail Sketch

This sketch should organize the middle values, the heart and soul of most paintings, nailing down the composition. On the right side, note how the middle values are combined into a supershape that includes the house in shadow, the tree leaves, the foreground bushes and the shadows on the ground.

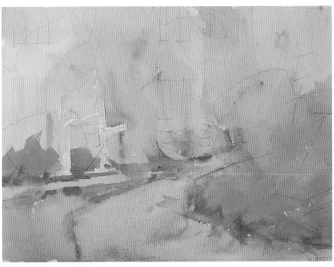

The Block In

At the end of the day, light changes rapidly, and there's no time to fuss with unimportant details. Concentrate on blocking in the colors and values of your lights. The payoff for getting it right is added freshness in the finished work.

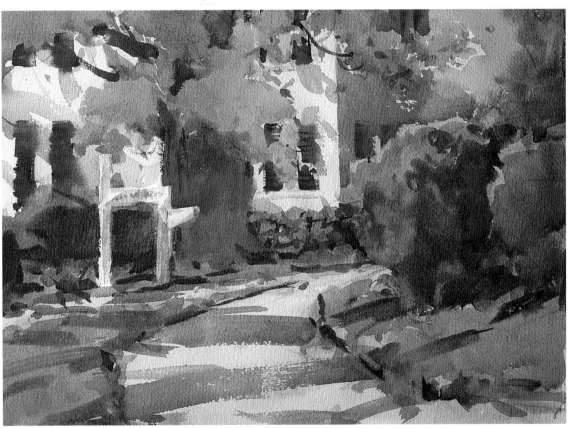

The Finished Piece

Notice the large, connected middle-value shapes. Color changes between the different elements, such as the house shadow, bushes and ground shadows, are enough to separate and describe each element. The paint is fresh and clean, and the finished work is very evocative of the subject.

MAPLE WOODS FARM
Watercolor on Arches 140-lb.
(300gsm) rough paper
11″ × 15″ (28cm × 38cm)

Three-Value Sketch

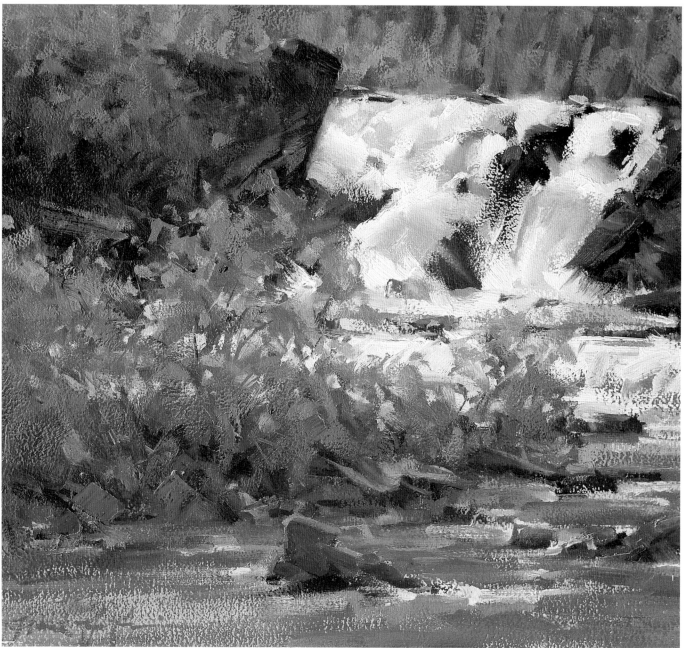

In art, nature often requires some editing by the artist. In the thumbnail for Glacier National Park, *the dark band on each side of the waterfall is an area that includes rocks and foliage. In reality, it's chopped up between dark, middle-dark and middle values. The sketch simplifies it into a dark shape, relying on color changes to identify the various individual elements.*

GLACIER NATIONAL PARK
Oil on panel
12″ × 16″ (30cm × 41cm)

Three-Value Sketch

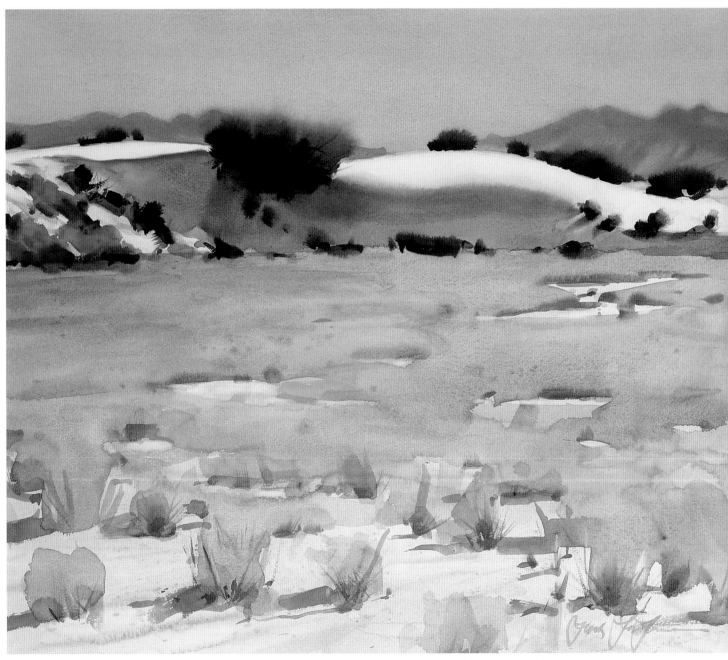

For White Sands National Monument, *the large shape of the ground cover, from the middle ground to the foreground, was simplified into a light middle value. The large shape contributes to a more effective design, while the color changes within that shape add interest and describe the desert scrub.*

WHITE SANDS NATIONAL MONUMENT
Watercolor on Winsor & Newton 140-lb.
(300gsm) cold-press paper
20″ × 24″ (51cm × 61cm)

Value Control

Value control is critical to the simplification process. It ensures that the overall simplicity and strength of your design isn't compromised. Each of the three values are like *value families*. The *light* family has a dark and light within it. The same is true of the *middle* and *dark* families. Each must retain its integrity. For example, the middle-value family, with its darks and lights, must still read as a middle value. If the darks within this family become too dark, it crosses the line and becomes part of the dark family. At this point, the integrity of both the middle and dark value families has been compromised. A few mistakes can cause the entire value structure to collapse.

Value control unites each of these three value families. For example, the green ground cover has a light and a dark as well as a color change in the distance, but the shape retains its integrity as a middle value. The pine trees, representing the dark values, also have a light and a dark, but the shape retains its integrity as a dark value.

Sometimes it is far from certain whether a given element falls within one value or another. For example, often a value in nature is somewhere between a middle and a dark. Preliminary work is an opportunity to experiment with different possibilities. Try a tree as a middle value in one sketch and as a dark value in another. Which value works best? In a thumbnail it is easy to arrange and rearrange the pieces. When in doubt, go with larger shapes and a more simple design.

Squinting it down while on location will help you to keep on track, as does stepping back and viewing it from a distance. (The value pattern should hold together when the painting is viewed from across the room.) By discovering the wonderful variety of color and texture within a disciplined design, you will produce a stronger painting.

The Scene

Create a Sketch
Start to organize all the wonderful chaos (the rich texture of the hillside and its abundant wildflowers) by drawing the essential lines.

Add Values
Organize the information a step further by simplifying what you see into three values: light, middle and dark.

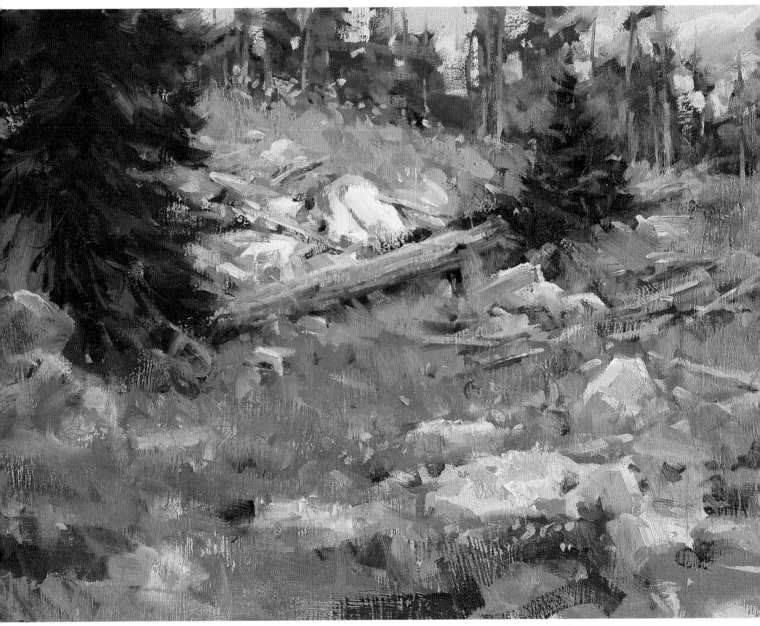

The Finished Painting

Note the value families in this painting: the lights, consisting of the rocks and downed timber; the middle values as the green ground cover; and the dark values as the pine trees and a few accents.

MEDICINE BOW
NATIONAL FOREST
Oil on panel
12" × 16" (30cm × 41cm)

STATE IT

State it refers to painting with authority. It was a term often used by the late American artist Millard Sheets. He would say: "Don't search with your brush. State it!" The time for searching is during your preliminary work. Decisions too close to call need to be made routinely. Once decided, however, you can proceed with confidence.

In phase one (see it), you made an effort to understand the essence of the subject. In phase two (simplify it), you organized the material into a coherent road map. Now, in phase three, you can state it because there is something to state.

State it combines visual perception with painting technique. Your technique is an extension of how you see the world and what you have to say about it. This should be the driving force that animates how you paint.

Plein air painting is the most natural and honest way to learn how to paint while retaining your innate individuality along the way. Painting from life is not technique-oriented. It's driven by a different impulse. When you are painting what you see and that is changing right in front of your eyes, it's imperative to get it down any way you can. As you develop the ability to state it, your work will take on a more expressive quality.

Along with direct observations of nature comes intuitive ideas on different ways of handling paint. Don't hold on to preconceived ideas or formulas on how to paint things. Good technique is fluid and spontaneous. New ideas will arise if you let them. Learning a bag of tricks and techniques without a corresponding ability to see clearly is like having the rhinestones but not the dress.

Students love to argue that their in-

experience makes it impossible to state it. While I am sympathetic to such thinking, it also occurs to me that if you are going to crash and burn anyway, why not go down in a blaze of glory? Why make the same little mistakes over and over in a seemingly perpetual loop? Make new mistakes. Huge mistakes! Just do it with an eye on the big picture, which is the color and value relationships organized into three-value sketches.

I am not suggesting a slap-dash approach. On the contrary, take all the time you need. Make careful decisions, then state it. Don't wait for that great someday when it will be easy to paint with authority. Take a leap of faith, for a painting done confidently with a naive technique is always more interesting than one that is technically well done but painted with hesitation and doubt.

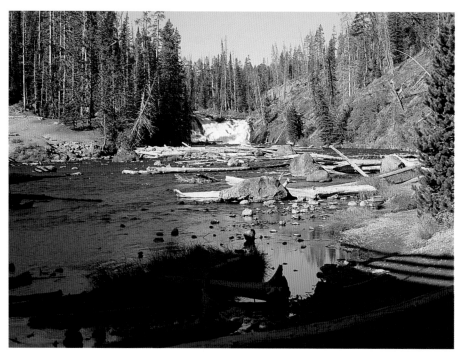

See It
Here, morning light warming the white water and the shadows falling across the foreground make for dramatic effects and an interesting value pattern.

Simplify It
Simplify what you see by creating a quick value sketch. This will help to organize the visual information and prepare you to state it. (Note: In some cases, you may be forced to go straight to stating what you see just to keep up with the changing light.)

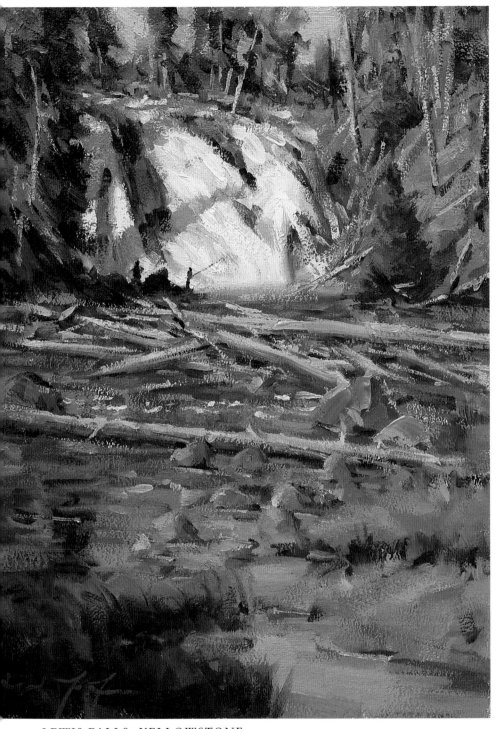

State It

The freshness and spontaneity of your brushwork is dependent on your ability to state it. Note the brushwork in the waterfall. This area is made up of thick paint, impasto over impasto. The numerous edges that the strokes created are important to the texture of the waterfall. Corrections at this stage will negatively impact the brushwork that was previously done, and a tentative approach will lead to overworking the painting.

STATE IT!

The ability to state it has practical consequences in all aspects of painting. Spontaneous application of technique produces expressive paintings. It's like a law of nature. Have the confidence to do what you have to do in a given circumstance and let the rest take care of itself.

LEWIS FALLS, YELLOWSTONE
NATIONAL PARK
Oil on panel
12″ × 16″ (30cm × 41cm)

This watercolor was painted on a glorious late-October morning using my half-size easel setup. A lot of the paint was mixed right on the paper. (Note the different colors in the adobe walls.) When mixing paint on the paper, the pigments will retain some of their individual color identity if they aren't overmixed. With accurate values, such effects can energize a painting and give it a great feeling of spontaneity. Playing fast and loose with the paint is a discipline and not the carefree or casual act that it might appear to be.

four PLEIN AIR PAINTING IN WATERCOLOR

Painting watercolors *en plein air* can yield breathtaking results, but it can also be problematic. Many important factors, such as drying time, are out of the artist's control. While there is an inherent, almost magical spontaneity to the medium, it also has a dark side in that it can be very unforgiving of even the smallest of errors. Plein air watercolors are a formidable challenge, and it helps to have a strategy to maximize chances for success. In this chapter, a direct approach to painting with watercolors outdoors will be discussed and illustrated. Step-by-step demonstrations will arm you with the skills necessary for plein air painting, from working with an ever-changing light source to creating a full range of edges (hard and soft) and skillfully managing the drying-time dilemma.

AUTUMN ON CANYON ROAD, SANTA FE, NEW MEXICO
Watercolor on Arches 140-lb.
(300gsm) cold-press paper
15" × 22" (38cm × 56cm)
Private collection of Mr. and Mrs. Shaw

A Direct Approach

The bottom line in each of the demonstrations in this chapter is a direct approach to using watercolor. This is mandated by factors out of our control, such as changing light and drying time.

LIGHT

When confronting a constantly changing light source, there is a premium for working at a decent pace, but never at the expense of the big picture, which is to make a profound observation and render it as simply as possible. A profound observation rendered simply is always more powerful than highly finished passages that don't fully relate to each other. The danger in spending a lot of time on one particular area is that the light will change, leaving the rest of the painting with color and value relationships that are weakly observed or worse, invented.

An important part of my direct approach to watercolor comes at the very beginning. You will notice that most of the demonstrations start with an *underpainting*. The underpainting has two primary functions: saving white paper where needed and painting the lights. The benefit in saving your white paper is obvious. Once it's gone, it's gone. You can add opaque white paint or even scrub some paint off a passage (lightening it in the process), but you will never achieve the clarity and luminosity in the lights that is possible with clean and accurate underpaintings.

The underpainting also paints the lights, an extremely important step. It is easier to accomplish subtle changes in color, value and temperature in the earliest stages of the painting. It is a delicate operation, demanding clean water and brushes. A good underpainting will lay the groundwork for the rest of the painting to follow.

As light changes throughout the day, so do the resulting effects. The warmth of early morning light is not as warm or intense as late afternoon. As the day progresses and the sun sets, light will increase in warmth and shadows will appear cooler and cooler.

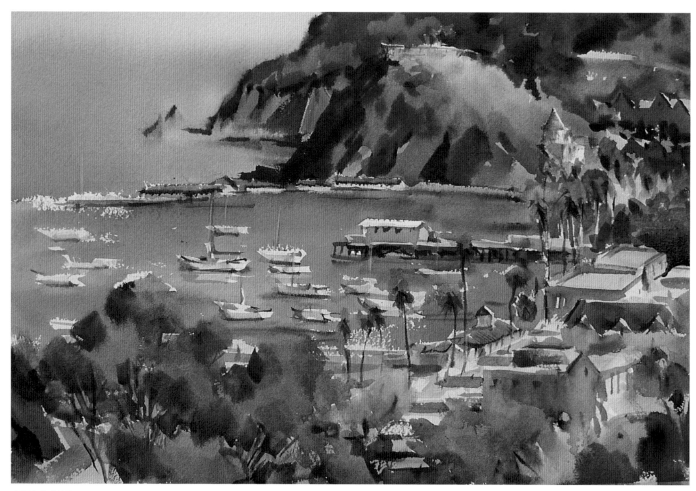

AVALON
Watercolor on Arches 300-lb. (640gsm) rough paper
15" × 22" (38cm × 56cm)
Private collection of Lisa and Dave Link

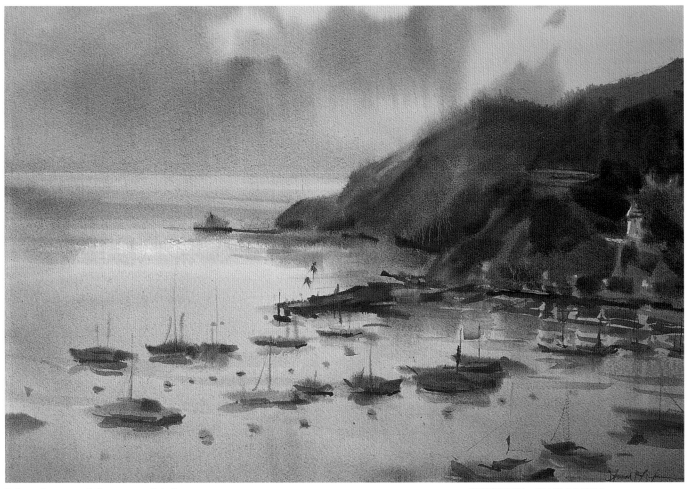

Morning vs. Afternoon Light
Life as a plein air painter is endlessly fascinating in that when you paint light, everything is new again. The main difference between these two watercolors is the quality of light. Sunrise, Catalina was painted in early morning; the light was diffused and filtered by clouds. Avalon was painted in the warm brilliance of the late afternoon.

SUNRISE, CATALINA
Watercolor on Arches 140-lb.
(300gsm) cold-press paper
15″ × 22″ (38cm × 56cm)
Private collection of Mary and
Robert Barrick

EDGES AND DRYING TIME
Another positive benefit of a direct approach is the creation of a full range of edges, from completely lost to razor sharp. Edges are a big part of the magic that turns two dimensions into three. Creating edges is one of the most difficult challenges faced by plein air watercolorists, for so much depends on factors that are out of their control. Variables, such as temperature, relative humidity, sunlight striking the paper and the brand of paper, all can play havoc with the drying time. Sometimes it's too slow; more often it's too fast. Oil paint, however, stays wet all day, a great advantage in manipulating edges.

Creating a range of edges with watercolors is a matter of controlling the amount of water on the paper versus the ratio of water-to-paint in the brush. Controlling these factors will take variables that are out of our control, such as humidity, and permit some control over drying time. If extensive wet-into-wet painting of a particular area is anticipated, then underpainting the area with two washes rather than one, or three instead of two, will extend the drying time. If you are painting under conditions of high humidity, then it would make sense to do the opposite, being careful not to soak the paper before accomplishing the main work of the piece.

One of the most common types of watercolors I see painted by students contains beautiful soft edges along with hard edges, but with little in between. By allowing the paper to dry completely, you eliminate the risk of coming in at the wrong time with an incorrectly loaded brush. However, you will also eliminate a potentially great asset, which is a full and beautiful range of edges.

Hard vs. Soft Edges

The heavy atmosphere of Songbirds in the Fog *created a range of soft edges. While most of the edges are soft, some are harder than others. Those relationships give the painting a true atmospheric effect. In this situation, the technical problem was to not get the sheet too wet too fast. High humidity allows very little opportunity for drying. By using less water in the earliest stages, it will allow some of the foreground passages to dry out (actually, become damp would be more accurate). This will enable those edges to appear harder.*

For Desert Tortoise, most of the painting was done on dry paper and soft edges were used for accent and variety. This piece uses hard edges similar to how Songbirds in the Fog *uses soft edges. The clarity and blanched quality of light creates a subtle range of hard edges.*

SONGBIRDS IN THE FOG
Watercolor on Arches 140-lb. (300gsm) rough paper
11" × 15" (28cm × 38cm)

DESERT TORTOISE
Watercolor on Strathmore rag bristol board (plate surface) 20" × 24" (51cm × 61cm)

Avalon

Painting Warm Afternoon Light on the California Coast

The first thing to do on location is size up the scene. Is there anything unusual about the subject that requires immediate action? Is there a prominent shadow that is quickly changing or perhaps a center of interest (maybe a figure) that may move or change? An unusual drying-time situation could mandate another approach.

In this particular case, there was nothing like that. While a change of light was to be expected, it looked like a fairly straightforward painting. In other words, any approach would work.

The most common question I am asked is, "Do you always start a painting this way?" or "Do you always do (whatever) that way?" My answer is always the same: No! Never! The greatest joy in being a painter is the ability to respond spontaneously to the subject. Don't cheat yourself out of this pleasure by holding preconceived ideas on how to paint.

This location was selected for an afternoon painting. One of my favorite times to work is in the warm light of late afternoon. As the days shorten toward winter, the light takes on an even warmer, more autumnal glow. The coastal atmosphere adds another special quality, the crisp light falling on the harbor contrasting with the wonderful softness of the mist-shrouded ocean horizon.

Because the subject is fairly complicated, full of many different elements, let's handle the watercolor in two stages. The first stage is to paint the distant area behind the harbor, where the harbor breakers jut out into the water, serving as a landing dock for the ferry. There is always a little white water at that point, which will help to integrate the top third with the rest of the painting. This strategy will enable you to fully concentrate on the atmospheric effect of the top third.

It makes sense to paint this area in a seamless operation because the soft edges of the atmospheric effect link the elements together. Once you begin painting this area, a tempo should be established. The degree of softness of any given edge will be a function of the drying process and coming in at the right time with the right amount of paint.

For the second stage, we'll work on the lower two-thirds, including the harbor and foreground. This portion will be more complex, with some drawing involved. The key to this stage is simplification, as well as getting it to blend with the top half, both in technique and in spirit.

MATERIALS

Paint
- Da Vinci Watercolors
 - Hansa Yellow Light
 - Gamboge Hue
 - Cadmium Red Light
 - Red Rose Deep
 - Ultramarine Blue
 - Cobalt Blue
 - Viridian
- Utrecht Watercolor
 - Permanent Violet

Brushes
- 1½-inch (38mm) sable wash
- 1-inch (25mm) Kolinsky sable flat
- Nos. 4, 8, 12 and 16 rounds (Prolene brushes, a blend of sable and synthetic hair, were used here)

Paper
- Sketchbook
- Arches 300-lb. (640gsm) rough watercolor paper (taped to a drawing board with masking tape)

Other
- Pencil
- Box of tissues (to clean your palette)
- Masking tape

1 Create a Preliminary Sketch

To simplify and organize so many different elements, take five minutes to sketch out the composition, placing the big shapes and their relative values. Create an interesting value pattern. Individual elements and details will be added later. (Don't waste valuable working time while the light is changing.)

2 Lay in the Initial Wash

Paint the sky and water areas with a light wash of Red Rose Deep and Gamboge. This wash will add warmth to the sky and water, as well as wet the paper. The sky should be a lighter wash (in value and color) than the underpainting for the water. (Color and value are important. If this wash is too red, it will turn the sky violet; if it's too yellow, it will make the sky green.) While still wet, paint a second wash of pure Cobalt Blue. Turn your drawing board upside down, allowing the water to run in the opposite direction, and paint the blue wash in reverse, ending at the top of the sky. Turn the board right side up and let the water run in the other direction. (Rotating the board will equalize the drying process.) The color of your sky should now be accurate, the warm underpainting appropriate to the amount of warmth in the sky.

3 Paint the Atmospheric Effect of the Background

For the ocean, mix a wash of Cobalt Blue with a touch of Ultramarine Blue. While the sky is still wet, make confident vertical strokes starting at the horizon and going down through the water to the breakers. Squint it down to see if it's dark enough. If you need to darken it, do so now while the paper is still wet. When the value is right, turn the board upside down and let the water soften into the sky. Next, using a no. 16 round (or a no. 12 or 1-inch [25mm] flat), paint the hills behind the harbor with a warm underpainting of Gamboge and Cadmium Red Light, varied with touches of Viridian and Permanent Violet. Leave the house on top of the hill white for now.

Most important edge Soft edge

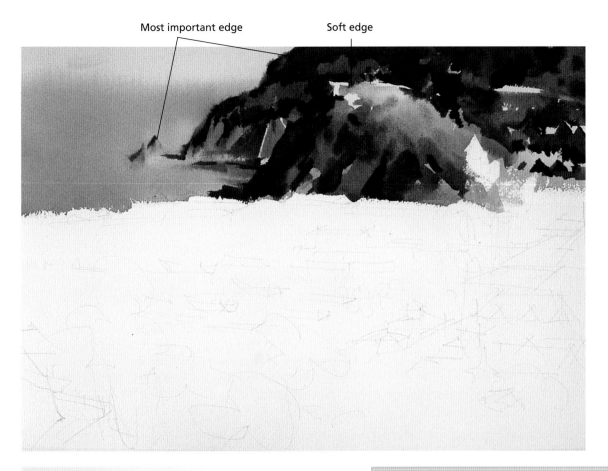

4 Finish the Background

Using mixtures of Ultramarine Blue, Cobalt Blue, Gamboge, Hansa Yellow Light, Red Rose Deep and Cadmium Red Light, paint the middle value of the hillside, mixing the colors directly on the paper. If the value is right, the softening and mingling of colors will produce a good atmospheric effect. Before that wash dries, use a warm dark, such as a mixture of Permanent Violet and a touch of Viridian and Cadmium Red Light, to model the hillside. By painting the darker shadows of the hills on damp paper, you will produce soft edges. Don't forget your most important edge, which is between the hillside and the water.

Notice the soft edge that occurs between the light-struck hill (the underpainting) and the middle value of the darker green hill behind it. If this edge is hard, your tempo is off. You can adjust it by either painting faster or by using more water (and paint) in your underpainting (so that the paper will stay wet longer), or both.

For the architecture, use the light of the underpainting to establish their lights. Paint the shadow of the white house on top of the hill with Cadmium Red Light and Cobalt Blue. For the structure with a series of pointed roofs (far right), use Cadmium Red Light and Ultramarine Blue for the dark under the light roof, mixing the paint on the paper.

THINGS TO REMEMBER:

- One of the most common student mistakes is not using enough paint. I cannot stress this enough. Paint is expensive, but it is cheaper than your time. My advice is to squeeze out at least twice as much paint as you think you will need, then use it all!
- If your paper is soaking wet and your values are still too light, then you are using too much water, a common mistake. Controlling watercolor means controlling the amount of water you are using. With each successive wet-into-wet wash, use less water and more pigment in the brush. The wet paper will supply much of the water you need. Frequently remove excess water from your palette as you work, either with tissues or by turning your palette over, shaking out the water.

5 Underpaint the Boats and Water

Afternoon sunlight is warm, and the underpainting should illustrate that (white paper alone is not sufficient). Paint the lights using mixtures of Red Rose Deep, Gamboge and Hansa Yellow Light, with a few touches of Ultramarine Blue. (Use a minimal amount of water to limit the drying time.) The value is critical. If the wash is too light, it will be ineffectual. If it's too dark, the boats won't read as white. (Every time you have to go back and repaint a passage, it will cost you in the overall freshness of the finished painting.) The darkest part of the wash is under the middleground hill. Leave a few strategically placed portions of white paper exposed for accents.

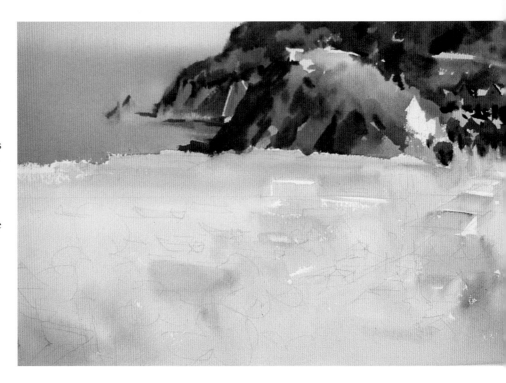

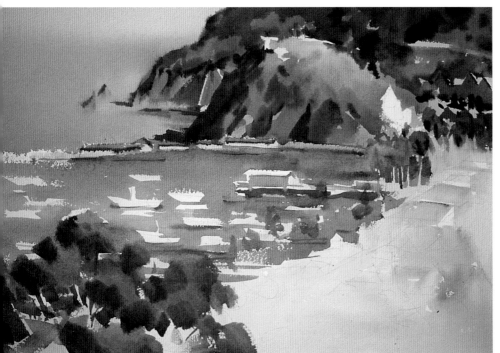

6 Paint the Water

Paint the water using a wash of Ultramarine Blue with a touch of Cobalt Blue and a 1-inch (25mm) brush. Be aware of your edges as you paint around the white shapes of the boats and pier, and add some drybrush edges for variety. Paint over the areas of the trees in the lower left corner, leaving some underpainting for a few tree trunks. Restate this wash with a slightly darker version of the same color (one that has less water in the brush and more pigment). Finally, paint the trees into the wet paint of the water with mixtures of Ultramarine Blue, Gamboge and a touch of Cadmium Red Light. Also place trees in the upper right corner of the wash, taking advantage of the wet paper. Paint the hill in the lower left using mixtures of Cadmium Red Light and Ultramarine Blue, with a touch of Gamboge.

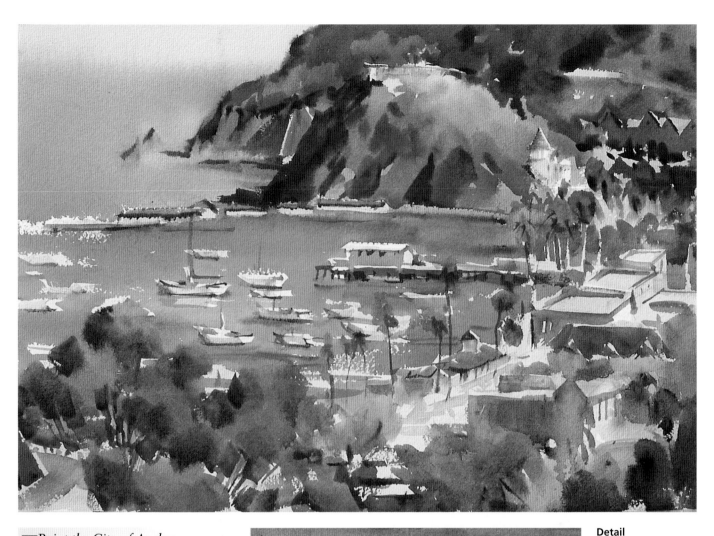

7 Paint the City of Avalon

This area will test your ability to simplify in a meaningful way. Remember that you are after the atmospheric effect, and overrendering does not fit that job description. The key is to find the large middle-value shapes (squint it down) that include both the foliage and buildings in shadow. Separate the color changes with soft edges. Paint the buildings' shadows with combinations of Ultramarine Blue and Cobalt Blue, Cadmium Red Light and Gamboge. For the foliage, use Viridian, Permanent Violet, Ultramarine Blue and both yellows. Use a midsize round brush (no. 12 or 16) and keep the edges of the large middle-value shapes soft. A little detail at the end will pull it together and identify individual elements.

Detail
Add the boat shadows, using Cobalt Blue with touches of Red Rose Deep and Hansa Yellow Light. Also add a few color accents on the boats. The reflections are painted with the same color as the boat shadows, but slightly darker.

Detail
Be careful not to over-render the architecture. Concentrate on the change of planes and the light and shadow it will produce. Windows and details are of secondary importance.

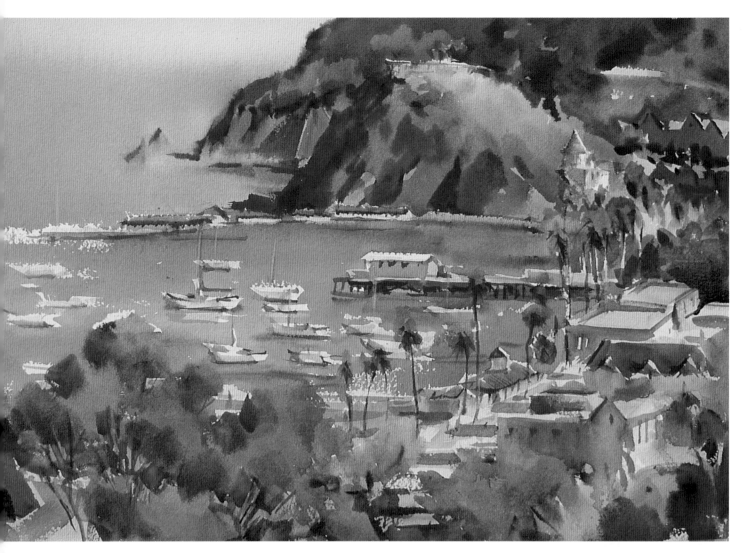

8 Pull It All Together

The light effect is now in place, and the only things left to do are a few refinements. Paint the shadows across the street with Cobalt Blue, Red Rose Deep and a touch of Hansa Yellow Light. Darken a few lights at the bottom-center and among the trees using Ultramarine Blue, with touches of Red Rose Deep and Gamboge. Add some calligraphy (a few details) to the closer buildings, adding just enough to identify them as architecture. When in doubt about which details to include, squint it down. Use only those details that remain most prominent.

Calligraphy works best on damp paper (dry paper will produce hard edges that may be distracting), and be sure that the values are not too dark (excessive value contrast can be as distracting as hard edges).

AVALON
Watercolor on Arches 300-lb.
(640gsm) rough paper
15" × 22" (38cm × 56cm)
Private collection of Lisa and Dave Link

Autumn in the Mad River Valley

Painting on a Cool, Damp Day

This watercolor was painted on a cold and windy day. It had been snowing earlier that morning, a fatal condition for plein air watercolorists.

This was a very interesting subject, but there were a number of problem areas to be aware of. First was the atmospheric condition. You should anticipate a slower-than-average drying time when painting in the cold and dampness. An adjustment in technique is required, particularly in the early stages so the paper won't become too wet too fast. Here, the nature of the day called for a simple, direct and accurate approach.

The other possible trouble spot was in the complicated nature of the subject. The scale of the various elements is important to conveying a sense of place in this particular landscape. Once the scale is accurate, then good edges are necessary to knit it all together.

First start with a few drawings, spending a little more time than usual due to the complicated nature of the subject. (I also had an ulterior motive: The weather was starting to cooperate; it was slowly warming up and drying out.) Once finished, you are ready to start painting.

MATERIALS

Paint
- Da Vinci Watercolors
 Hansa Yellow Light
 Gamboge Hue
 Red Rose Deep
 Cobalt Blue
 Viridian
- Holbein Watercolors
 Cadmium Red Light
 Ultramarine Blue
 Deep

Brushes
- 2-inch (51mm) Skyflow wash by Robert Simmons
- 1-inch (25mm) Kolinsky sable flat
- ¾-inch (19mm) Kolinsky sable flat
- Nos. 8, 12, 16 Prolene (blend of synthetic and sable) rounds

Paper
- Sketchbook
- Arches 140-lb. (300gsm) rough paper

Other
- 2B pencil
- Box of tissues

A NOTE ON WATERCOLOR TECHNIQUE

When painting watercolors outdoors, you will need to compensate for atmospheric conditions out of your control. If you are in a humid area, paint the underpainting with a minimum of water so it will dry more quickly. Also place your drawing board at a steeper angle so the water will run down quicker, superficially wetting the surface rather than soaking it. In arid, desertlike conditions, however, adjust your board to rest at less of an angle and use additional washes (for example, two rather than one) to accomplished the desired effects.

1 Start With a Drawing
This is an excellent way to familiarize yourself with the subject and any complicated elements.

2 Create a Value Sketch
Break down the subject into large, basic shapes. Use the three values (light, middle and dark) to establish the value pattern and organize your composition. (Don't focus on details, these will be added later.)

3 Begin the Underpainting

Begin in the sky using a warm wash of Red Rose Deep and Hansa Yellow Light. The degree of warmth in the sky is unique and indigenous to each individual locale. Pull the sky wash down to the water level. Add some Cadmium Red Light to the distant mountain. For the trees and ground, add some Gamboge and a touch of Viridian. (Note: The lights on the house, the roof of the bridge and the warmth of the sky are critical. The underpainting over the areas of the middle value are less important at this early stage.)

4 Finish the Underpainting

Paint the water area using a light wash of Cadmium Red Light and Gamboge. Note the drybrush effect as the strokes break up at the dam. This will be the only white paper left in the finished painting. It will effectively provide sparkle because its white is different than the white of the house. (The white at the bottom of the waterfall will be painted over.) Paint the waterfall with a cool mixture of Cobalt Blue and Cadmium Red Light, and the retaining wall with red predominating. Underpaint the rocks on the side and bottom with Gamboge, Red Rose Deep and Viridian. Connect the light shape of the rock (right) to the water.

5 Paint the Sky and Distant Hill

Paint the cloud shadows with Cadmium Red Light, Cobalt Blue and a touch of Hansa Yellow Light. While the paint is still wet, paint the sky with pure Cobalt Blue. (The light of the clouds is now the warm underpainting.) While the sky is still damp, paint the distant mountains with mixtures of Red Rose Deep, Cadmium Red Light, Gamboge, Viridian and Ultramarine Blue. These color changes should occur within the middle value family. If they are too light, restate them while the paper is still damp. Keep the edges soft. Start the trees around the house with Gamboge and touches of Ultramarine Blue mixed with Red Rose Deep.

6 Paint the Covered Bridge and Middle Ground

With your 1-inch (25mm) sable, add some darks to the top edge of the bridge's roof, which should already have a combination of hard and soft edges. Paint the side of the bridge in two washes, mixed directly on the paper, using pure Viridian mixed with some Cobalt Blue and Cadmium Red Light over that. Add the darks while the wash is still damp, using Ultramarine Blue mixed with Cadmium Red Light, Red Rose Deep and Gamboge. Paint the retaining wall with the same colors using some wet-into-wet calligraphy. For the house shadow, use Cobalt Blue, Cadmium Red Light and a touch of Hansa Yellow Light. For the grass, use Gamboge, Ultramarine Blue and a touch of Red Rose Deep. Using your 1-inch (25mm) wash brush, paint the water with Red Rose Deep, Gamboge and Ultramarine Blue. Keep the water lighter under the bridge and darker near the house. Because the wind is breaking the water, there should be no clear reflections. Use long drybrush strokes to indicate the texture of the wind over the water.

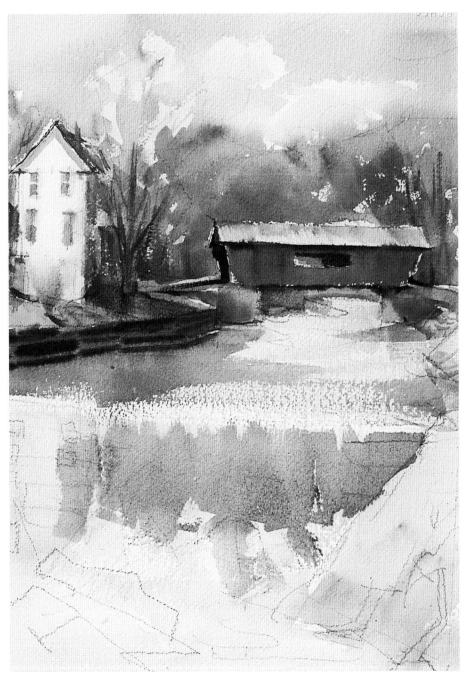

7 Finish the Middle Ground and Start the Waterfall

Darken the house (from ground up) with a light wash of Gamboge and Red Rose Deep, and paint the windows wet-into-wet. Restate the house and windows as the paper dries, creating a variety of edges. Darken the roof of the house as well as the trees on both sides. Paint the neutral green bush with Viridian, Red Rose Deep and Hansa Yellow Light. Begin the waterfall with a middle-value wash of Ultramarine Blue, Red Rose Deep and a touch of Hansa Yellow Light. This wash is the light of the waterfall in shadow and it needs to be a solid middle value. If this wash is too light, the three-dimensional effect will be lost. Paint it with upward strokes, creating a nice edge on top.

8 *Paint the Waterfall*

First, paint the dam on each side of the waterfall using a dark value of Ultramarine Blue, Cadmium Red Light, Viridian and a touch of Gamboge. Paint the darker strokes, indicating the logs, over the first dark wash. The waterfall is transparent and the dark, when looking through the falling water, is cooler. Using the same mixtures as above but with Viridian and Ultramarine Blue predominating, paint the dark within the waterfall using upward strokes. Add some darker vertical strokes to suggest logs. The water (the previous middle-value wash) should still be damp. Keep these edges soft.

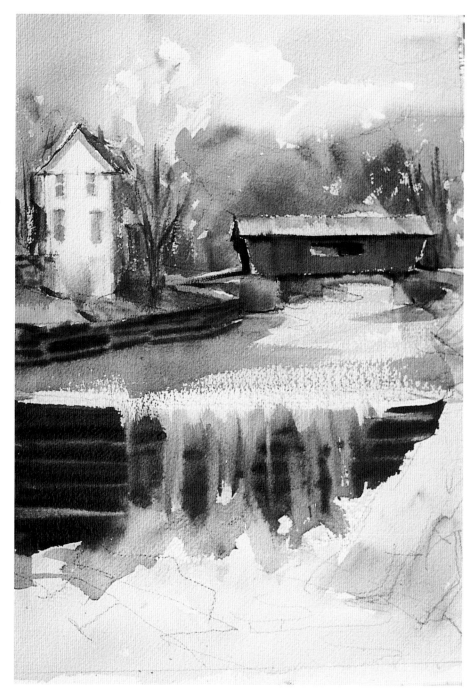

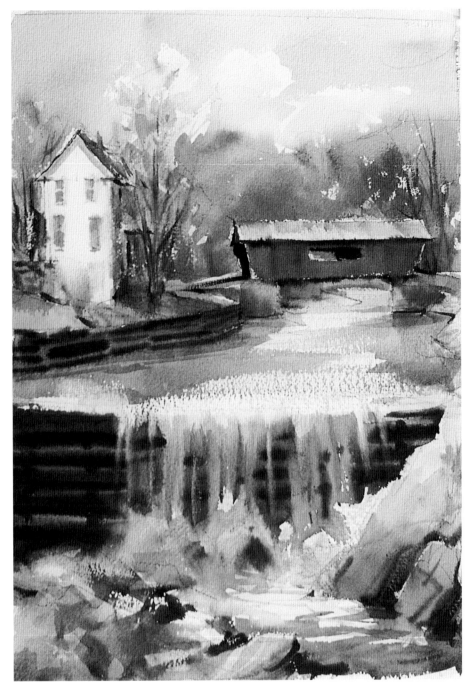

9 Finish the Foreground

Paint the rocks on both sides of the waterfall with Red Rose Deep, Gamboge and Ultramarine Blue. Darken and cool the rocks on the right as they near the water, with the addition of Viridian. Where the waterfall is breaking over some rocks, paint wet-into-wet with Ultramarine Blue, Red Rose Deep and Gamboge. Keep this area simple while using a variety of edges as well as some drybrush strokes to suggest the various textures of rock and moving water. The only white paper that should remain is in a few sparkles at the left edge of the rock on the right. The rest of the white water's color and value has been carefully controlled. It is important to keep the plane of the waterfall in shadow.

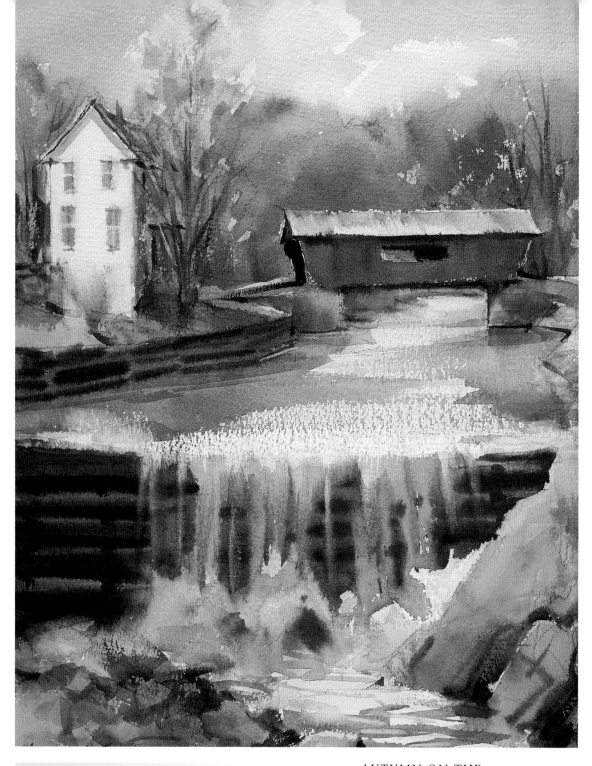

10 Add Finishing Touches

At this point, the main elements of your painting should be in place and any adjustments should be minor. Close any distracting sky holes between the mountain, sky and tree tops. Refine the bridge a bit, such as the dark bottom edge (strengthen on the right) and the top line of the roof (straighten). Simplify and slightly darken rocks at the bottom, pulling them more firmly into the middle-value family. Note: Keep your painting fresh. Don't ruin a good sketch by refining it into oblivion.

AUTUMN ON THE
MAD RIVER VALLEY
Watercolor on Arches 140-lb.
(300gsm) rough paper
15″ × 11″ (38cm × 28cm)

The Kirk House

Painting a White House in Bright, Late-Morning Light

This watercolor was painted in Avalon on Santa Catalina Island. I was cruising, looking for a place to set up, when I happened by the Kirk House. It was around 10:00 A.M., and I arrived in time to see the wonderful shadows as they appear in the finished painting. I watched in amazement at the speed with which the shadows moved. (It is very instructive to find such a controlled situation in which to observe light. Watching a shadow move across a white surface illustrates how light changes moment by moment.)

When you happen across a scene and realize that it's too late to capture the fleeting light effects, don't despair. Carefully make note of the time the light and shadows were perfect, then set up your easel and create a thumbnail sketch. Next, carefully draw the composition on your painting surface. There's no need to create a detailed rendering, but accuracy is important. Once your drawing is finished, start and complete an underpainting on site. Return the next day an hour early and set up. With the drawing and underpainting already in place, the piece will practically paint itself.

MATERIALS

Paint
- Da Vinci Watercolors
 Hansa Yellow Light
 Gamboge Hue
 Ultramarine Blue
 Cobalt Blue
 Cadmium Red Light
 Red Rose Deep
- Utrecht Watercolor
 Permanent Violet

Brushes
- 1½-inch (38mm) sable wash
- 1-inch (25mm) Kolinsky sable flat
- Nos. 4 and 8 Kolinsky sable rounds
- Nos. 12 and 16 Prolene rounds

Paper
- Sketchbook

- Kilimanjaro 140-lb. (300gsm) cold-press watercolor paper taped to a drawing board with masking tape (Kilimanjaro is a good, bright white paper)

Other
- Pencil
- Masking tape
- White clip-on umbrella

1 Create a Preliminary Sketch
This thumbnail sketch is intended to organize your material into a composition with big shapes and clear-cut value separation, and serve as a road map for the painting to come. Be certain to include the interesting value patterns resulting from the direct sunlight and dramatic shadows.

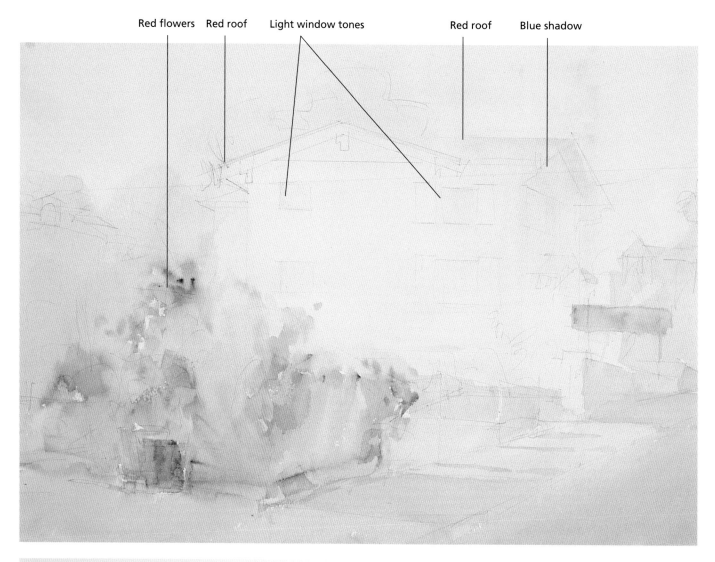

Red flowers Red roof Light window tones Red roof Blue shadow

2 Start With the Underpainting

The house is warmed by sunshine. White paper alone won't convey that warmth. Start by painting the house with a light wash of Gamboge and a touch of Red Rose Deep. Keep it slightly darker and warmer at the bottom. Underpaint the sky with a darker version of that wash, darkening the left side with Cobalt Blue. Put in the area of foliage (in the lower left), allowing the pure pigments to run together. Paint the foreground with mixtures of Cadmium Red Light, Cobalt Blue and Gamboge. Keep the edges soft throughout the underpainting.

(The underpainting of this piece is a little unusual. Knowing that I was going to return the next day, I used more wet-into-wet for the underpainting. Notice the red roof, the blue shadow on the right side of the house, the light tones in the windows and the red flowers. These were all painted wet-into-wet. Normally this practice would wet the paper too much, too early. If the paper gets too wet in the earliest stages, the delay in drying out could cost you your tempo in missing the changing light. In this situation, however, that wasn't a factor.)

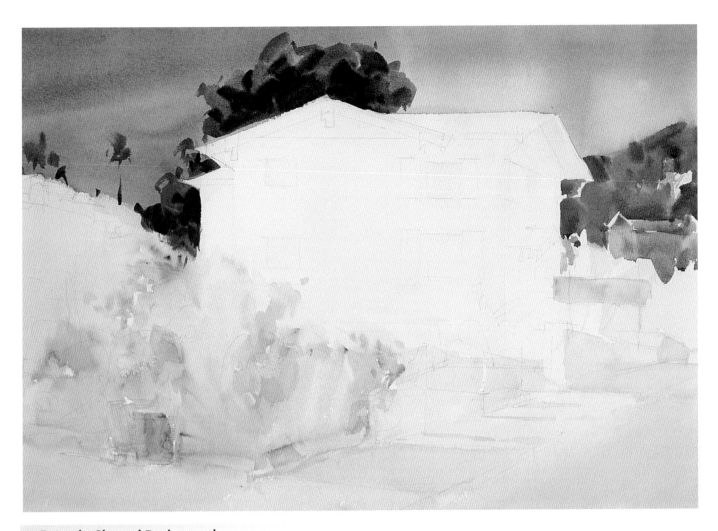

3 Paint the Sky and Background

One of the most critical observations is the color and value of the sky in relation to the color and value of the shadow. Start by restating the sky with a light wash of Red Rose Deep and a touch of Hansa Yellow Light. This wash will rewet the sky area. With your large brush, paint the sky with Ultramarine Blue and a touch of Cobalt Blue. If it is not dark enough, restate it while the paper is still wet. While the sky is still damp, paint the foliage and the distant hill (on the right). Keep the edges soft.

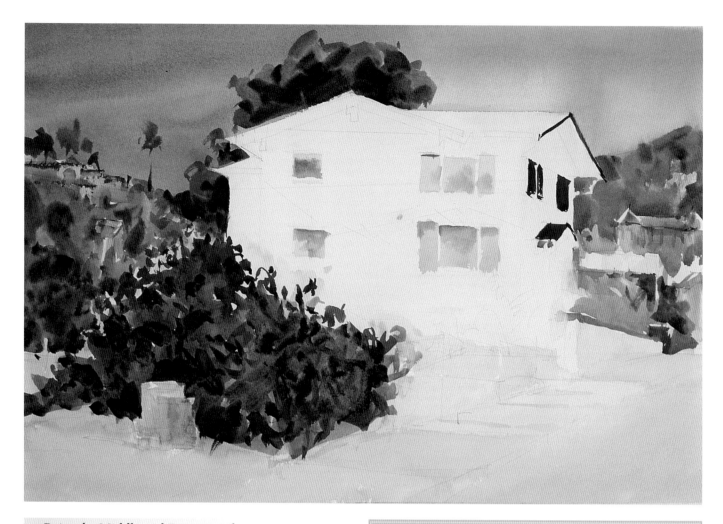

4 Paint the Middle and Foreground

Paint the windows with Hansa Yellow Light, Red Rose Deep and Cobalt Blue. (The glass should pick up reflected color from the landscape. Look at the value first, then at the color changes within it.) Add the dark windows and receding roof line. Paint the estate on the hill (to the left) simply with Gamboge, Cadmium Red Light and Ultramarine Blue. Connect the flowers (Red Rose Deep) to the distant hill with soft edges. This mass of foliage (in the foreground) is warmer than the distant hill. Mix this color on the paper using Ultramarine Blue, Gamboge and a touch of Red Rose Deep. Keep the darks warm and the edges soft.

MIXING COLOR ON YOUR PAPER

Not only is it great fun, but it also produces effects unique to watercolor. When mixing paint on your paper, value control is a more subtle operation. If you are mixing a middle value with two washes of pure color, then each one must be the correct value so that when combined, the final value is what you need.

The effects of this technique can energize your painting and create passages of wild spontaneity. When that occurs within the context of an accurate and subtle observation, then you are using the watercolor medium for all it's worth. The shadow on the Kirk house is a good example of this technique in action.

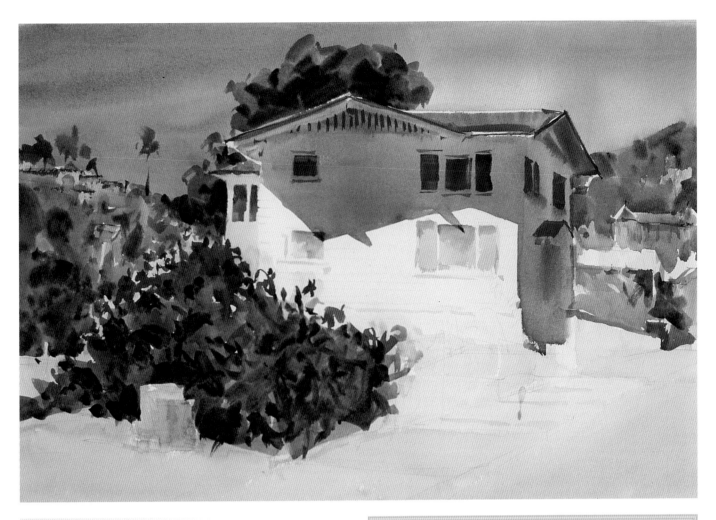

5 Paint the Shadows

The shadow shape on the house is a cool middle value, close in value to the sky, with violet overtones. It is slightly bluer at the sunlit edge and a little warmer under the eaves. In addition, there is some warm reflected light under the eaves on both planes of the house. These subtle color changes occur while holding the value. (Value changes within the shadow will compromise its integrity as a shadow.) Also, edges within the shadow are softer than those in the light.

Paint the shadow in two simple washes. Start with a wash of Red Rose Deep and Hansa Yellow Light (with red dominating). Make this wash slightly lighter at the shadow line and slightly darker near the roof. Paint the second wash over the first (wet-into-wet) using Ultramarine Blue with a touch of Cobalt Blue. While the paper is still wet, paint the warm reflected light on the receding plane of the house with one stroke of pure Hansa Yellow and the reflected light on the near side with Gamboge. Darken the area under the entrance and eaves using a darker version of the shadow colors, and restate the windows in shadow. Add calligraphy, or details, while the paper is still damp.

SHADOWS AND UNDERPAINTINGS

The degree of warmth of a shadow is determined by its underpainting. The subtle gradations in that wash are based on your observations of the shadow. For example, in step five, keeping the red underpainting a little lighter along the shadow line will make the finished shadow appear a little cooler.

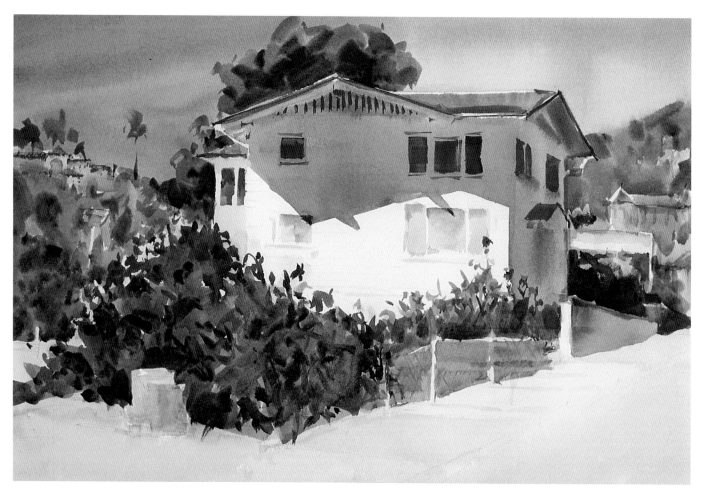

6 Paint the Foreground

Before painting the two retaining walls, recheck the accuracy of your drawing. Paint the walls simply, using Ultramarine Blue, Cadmium Red Light and Gamboge, and hold the middle value. (The gradation on the white wall appears a little more dramatic than the way I saw it, but I left it because it was interesting, cleanly done and not an outrageous exaggeration.) Paint the foliage using Ultramarine Blue, Gamboge and a touch of Red Rose Deep. For the wall, use Cobalt Blue, Hansa Yellow Light and Red Rose Deep. Keep the edges soft. Add calligraphy to the fence using a no. 4 round brush, Ultramarine Blue and Cadmium Red Light while the paper is damp. Carefully control the value (don't make it too dark). It should disappear when you squint it down.

REMEMBER

Exaggerating a direct observation always has a more powerful effect than inventing something.

Detail
Note the warm reflected light in the shadow on the retaining wall. Although the effect is exaggerated, the paint is clean and interesting. Sometimes exaggerations of color or gradation can look contrived and don't work. But when they are based on a direct observation and not invented, they can energize finished pieces.

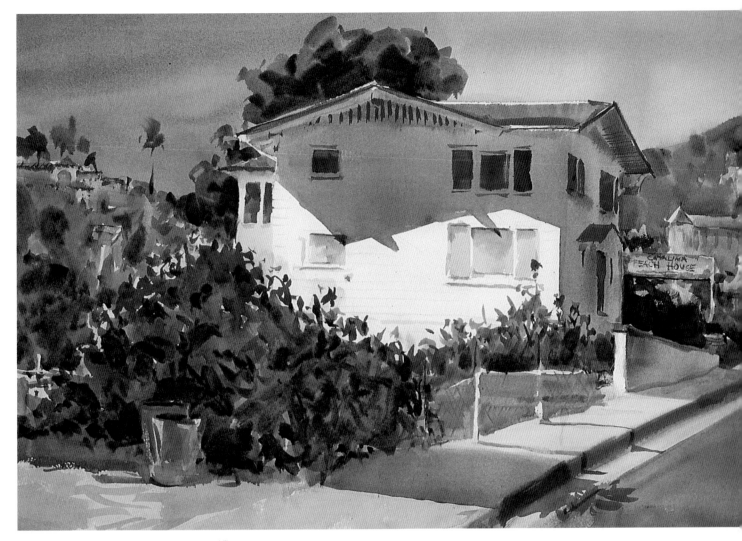

7 Add the Finishing Touches

The sidewalk is a warm light yet darker than the white house. Darken and warm the underpainting slightly, using Cadmium Red Light, Gamboge and a touch of Cobalt Blue. The street is a middle-value, more neutral than the house shadow. Paint the street (and the shadow) using Cadmium Red Light, Ultramarine Blue and a touch of Hansa Yellow. Keep the area under the flowers simple, avoiding excessive value contrast. (When you squint this area down, it should appear simple.)

At this stage of the painting, it's more important to simplify than add more detail. Squint it down and try to pull your big shapes together, if necessary. Glaze some of the light flowers using Red Rose Deep and Gamboge, so the lights of the flowers aren't as light as the lights of the house. Add details sparingly. Go slowly, spending more time looking than painting. When the big shapes are cleanly painted and accurate in their relationships, consider your painting finished.

THE KIRK HOUSE
Watercolor on Kilimanjaro 140-lb.
(300gsm) cold-press paper
15″ × 22″ (38cm × 56cm)
Private collection of the
Santa Catalina Island Company

This oil painting, created on a cold winter's day in northern New Mexico, demonstrates the possibilities offered by plein air painting in oil. Note how white paint is used to create the snow-covered landscape. Used incorrectly, white paint can result in chalky-looking paintings. Used correctly, however, and you can create dramatic, effective compositions.

PLEIN AIR PAINTING IN OIL

Oil paints offer great opportunities for the plein air artist. The secret of plein air painting lies not so much in the act of painting, but rather in the quality of the observation. Oil paint is well suited for this challenge. Oil paints stay wet all day, which allows for the working of edges as well as simplifying changes and adjustments. They are also more independent of atmospheric conditions, such as temperature and humidity. Both of these factors add up to a medium that will work with you in your attempt to capture the fleeting effects of light. Plein air oil painting is one of the great experiences that you, as an artist, can have. The three step-by-step demonstrations in this chapter offer insight, ideas and possibilities of this fascinating process.

ON THE HIGH ROAD TO TAOS
Oil on canvas
16" × 20" (41cm × 51cm)

The Chemistry of Oil Painting

You don't need to be a chemist to be an oil painter, but there is one concept that is important to understand. The old adage is "fat over lean." In other words, in order for the layers of paint to properly adhere, the initial layers must contain less oil (be leaner) than later applications (which have more oil and are fatter). For example, a turpentine wash, applied over paint used straight from the tube, would not have sufficient oil content to make a proper bond. This rule is most critical when the painting is made over a period of days, weeks or months, rather than when painted *alla prima*, or finished in one session.

THE PAINTING SURFACE

With oil paint, the artist creates the actual surface of the painting using a combination of transparent, semitransparent and opaque paint. This is in contrast to watercolor, where the paper functions as the actual surface of the painting.

Working on a Toned Ground

To tone or not to tone, that is the question. Is it better to work on a toned ground or a white canvas? This is an ongoing debate, and it is usually one of the first questions that arises in oil painting classes.

One great benefit of working on a toned, middle-value ground is that it simplifies hitting your values. When starting on a 50-percent value, it is easier to split the difference and mix a 25 (halfway between black and the middle-value ground)- or 75 (halfway between white and the middle-value ground)-percent value.

A toned ground also has a harmonizing effect on the painting as it acts as a uniting influence on the color harmony. Although this can be beneficial, such as in the painting above, it can also be a one-size-fits-all solution that detracts from a painting. For example,

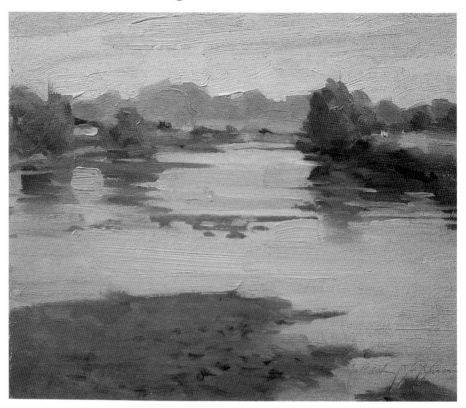

A toned ground can be an effective strategy on given occasions. For this piece, the light had a soft, warm glow, partially due to the late afternoon and partially due to the season (late fall). The preliminary wash of Cadmium Yellow Light, Quinacridone Red and a touch of Ultramarine Blue, set the stage for the light effect and color harmony.

AUTUMN ON THE RIO GRANDE
Oil on panel
10" × 8"
(25cm × 20cm)

when painting the clear, cool light of the high desert, a warm, middle-value ground can be a definite liability.

Working on a White Ground

Working on a white ground has similar pluses and minuses. The biggest plus is that a white ground gives a boost to transparent passages, resulting in more brilliant color. Pigments that are transparent in watercolor are also transparent in oil paint, for the same pigment is used in both. As with watercolor, the brilliance and clarity of transparent color in oil is maximized when it's applied over a white ground. When transparent paint is applied over a middle value, the optical mixing of the ground and the transparent wash over it will combine to form a third color.

For example, a wash of Ultramarine Blue over a middle-value ground of Burnt Sienna will produce neutral gray.

A white ground also has disadvantages. Working on a white ground can make hitting your values a little more difficult; you don't have the same comparative advantage of splitting the difference that working on a toned ground provides. Also, white canvas doesn't act as an artificial color harmonizer. Your colors will need to be harmonized the old-fashioned way: by using them skillfully.

For any given painting, the first decision you must make is what ground you will work on. When deciding which is best to use, a white canvas or a toned ground, just consider the implications of both, then choose.

PAINTING FROM DARK TO LIGHT

The traditional approach to oil painting is working from dark to light, for a number of reasons. Being an opaque medium, the thickest paint naturally occurs in the lights (with the addition of white paint). By starting with thin (lean) darks and gradually working up to the (fatter) lights, you will construct the paint film in an orderly and logical way. (Be careful not to get too much paint on the canvas too soon.) In the following demonstrations, blocking in will be done using thinner paint. Once you have correctly established the relationships and everything in its proper place, then you can begin to pile on the paint.

Another reason for working from dark to light is the nature of darks themselves. It is difficult to paint a rich, colorful and transparent dark if it is painted over mixtures that contain white paint. By placing the darks first, that problem is avoided. Thin, transparent darks (in a paint film consisting of transparent, semitransparent and opaque paint) adds greatly to the three-dimensional effect.

USING WHITE PAINT

One of the main differences between oil painting and transparent watercolor is the use of white paint. Too much white in a mixture will produce a weak, pasty-looking color. Whenever possible, lighten your mixtures by adding lighter-value pigments other than white. For example, yellow or orange will lighten most green mixtures (as well as warm them). This produces more saturated, vibrant colors than the same greens mixed with white paint. Cadmium Red Light will lighten the value of a dark mixture because the Cadmium Red Light is a middle value. However, this only works to a point. Sooner or later, white paint is necessary. By cutting back on the overuse of white paint, you will produce richer colors and more interesting paintings.

DRYING TIME

One of the great advantages of using oil paint is the drying time. The paint stays wet all day, which is very helpful when working edges and creating a number of interesting effects. It enables you to take a minute anywhere in the painting process to work out a problem, remix a particular color or just reexamine the direction the painting is going. The extended drying time also makes oil a more forgiving medium, allowing changes at almost any point in the painting.

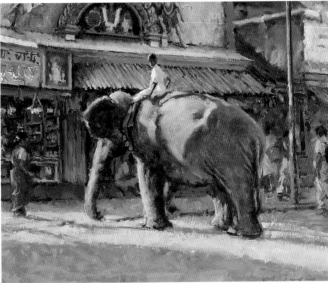

MADURI
INDIA
Oil on canvas
20″ × 24″
(51cm × 61cm)
Private collection

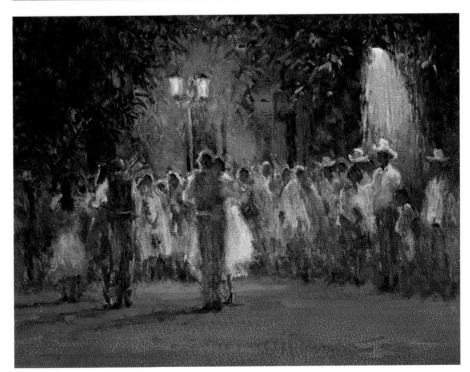

Incorrect vs. Correct Use of White Paint
Using white paint is an art within an art. Compare these two paintings and the use of white paint. In the top painting there are passages that appear a little chalky (the distant building, the awning and even the shadow in the foreground). In the second piece, however, white paint is used more judiciously, from a warm incandescent light above the dancers to the cool white light in the upper right.

TONIGHT'S
THE NIGHT
Oil on canvas
20″ × 24″
(51cm × 61cm)

Saint Mary River, Glacier National Park

Painting a Mountain in Shadow and Light

Saint Mary River, Glacier National Park was painted in northern Montana. Glacier contains some of the most beautiful and dramatic mountain scenery I have ever seen. Painting such scenes, however, can be problematic. When faced with landscapes that are so perfectly beautiful, you may be left to wonder what else you could possibly add. I have reflected on this question while painting at the Grand Canyon and a number of other places of great dramatic beauty. Nevertheless, the pure fun of trying usually carries the day. And besides, the goal of art is always more than just copying.

Here, the light had a special early-morning quality, which added to the park's feeling of grandeur. It felt big and awesome: feelings that I wanted to convey and the reason for trying this painting at this particular time. Sizing up the scene, the main potential problem was an imminent change of light. The morning atmosphere was bound to change too rapidly. When faced with situations such as this, create a quick pencil thumbnail, working out a composition, then set up in a hurry and begin painting.

THE GOAL OF ART

Art is more than just copying a particular subject. There is a reason why you are painting here and not there. Something about the subject caught your eye, whether it was a particular light effect or any number of other reasons. Although it takes technical skill to copy the subject, that alone is not enough to express the *why* of a given painting. That level of self-expression is the real goal of art.

MATERIALS

Paint
- Utrecht Oils
 Titanium White
 Cadmium Yellow Pale
 Cadmium Yellow Light
 Ultramarine Blue
 Cobalt Blue
 Cadmium Red Light
- Grumbacher Oil
 Quinacridone Red

Brushes
- Nos. 4, 6, 8 filberts
- Nos. 6, 10, 12 brights
- No. 12 flat
- Nos. 6, 10 rounds
- No. 8 sable round for drawing and detail work

Painting Surface
- 12" x 16" (30cm x 41cm), ⅛" (3mm) mahogany plywood sealed with a coat of acrylic gesso and primed with a white oil primer

Other
- Pencil
- Sketch paper
- Mineral spirits
- Palette knife
- Tissues

1 Create a Preliminary Sketch
To capture the morning light, sketch very quickly in anticipation of the imminent light change. You may even opt to stop sketching when you feel that you understand the value structure. This will often leave an unfinished and rather abstract-looking drawing. The goal of the sketch, however, is accomplished when you understand the large shapes and their relative values.

2 Begin Blocking In With Color

After placing the elements of your drawing, paint the green, middle-value ground shape using mixtures of Ultramarine Blue, both Cadmium Yellows and a touch of Cadmium Red Light. Keep the color changes simple and within the range of middle values. Thin the mixture with just enough mineral spirits so the paint is loose but doesn't drip or run.

For the mountain shadow, mix Cobalt Blue, Quinacridone Red and a touch of Cadmium Yellow Light and white. Lighten this tone as it nears ground level using a little more white. For the light of the mountain, use the same pigments with red and yellow predominating. Paint the warm light of the sandbar in the foreground with Cadmium Yellow Light, Quinacridone Red, white and a touch of Cobalt Blue. Compare the value of the sandbar to the mountain and foliage. In this early stage, getting the relationships between the elements properly aligned is more important than painting trees or mountains.

3 Paint the Sky and Mountains

Getting the correct amount of warmth in the sky is important to the overall atmospheric effect. Block in the sky using mixtures of white, Cadmium Yellow Light, Cobalt Blue and a touch of Quinacridone Red, all thinned with mineral spirits. Soften the edge between the sky and mountains using a clean bristle brush. The lights of the distant mountains are slightly darker and more neutral than the lights of the closer mountain, and the darks of the distant mountains are lighter. Begin the foreground (the area under the green middle-value) using Cadmium Red Light, Cadmium Yellow Light and touches of Ultramarine Blue and white. The adjacent piece of water has a violet cast. Add a little Quinacridone Red to Cobalt Blue with a touch of Cadmium Yellow Light and white. Double-check the value of the water against the value of the sky. (The water should be darker.)

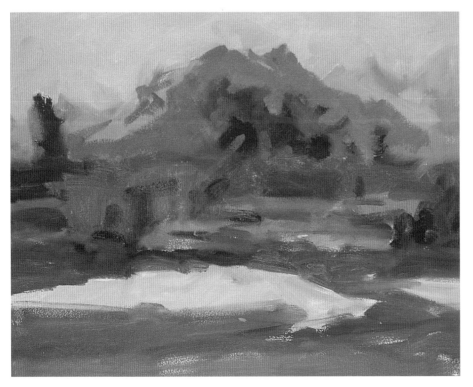

4 Complete the Block-in

Establish the water of the river as a middle value. Block in the water with mixtures of Ultramarine Blue and Cadmium Yellow Pale, with touches of Cadmium Red Light and white. There is a color change below the sandbar (add Cobalt Blue) and another at the bottom of the panel (add Cadmium Yellow Pale). Keep these color changes within the middle-value range and the edges soft.

(This is a good point to take a moment to clean your palette, squeeze out more paint if necessary and generally prepare for the finished painting to come.)

5 Finish the Background, Begin the Middle Ground

Begin the finishing process in the distance. With a no. 10 or 12 bright or flat bristle brush, paint the sky using the same colors as used in step three, unthinned. (The mixture should be warmer at the horizon and cooler at the top.) Maintain a sharp edge between the mountain and sky on the light-struck side (left), and soften the other edges. Pull the wet paint of the closer mountain down, blending into the tree area, and paint the tree lights using Ultramarine Blue and Cadmium Yellow Light, with touches of Cadmium Red Light and white. Soften the edges.

Restate the darks at the bottom of the trees with thicker paint, and begin the middle ground with brushstrokes of Ultramarine Blue and Cadmium Yellow Light, with touches of Cadmium Red Light and white. Keep the light of the ground lighter than the tree lights. When you are convinced of its accuracy, then it's time to use thicker paint in your brushstrokes. Paint the ground cover using mixtures of Ultramarine Blue, Cadmium Yellow Pale and touches of Quinacridone Red and white. Finally, paint the distant water (behind the tree) using Cobalt Blue, white and touches of Quinacridone Red and Cadmium Yellow Pale. (The water should be slightly darker and more violet than the sky and darker behind the trees.) Keep it simple.

Detail
When working your edges, look for the sharpest and softest edges, and use them for comparison. The edges of the tree silhouette are softer than the edges on the nearby mountain. Sometimes an edge will be sharper on one side of a brushstroke and softer on the other. (For example, the lights on the left side of the mountain.) Also, note the color changes in the lights on the mountain. The lights are lighter and warmer on the left and slightly darker on the right (above the trees).

6 Complete the Middle Ground

Include some closely observed color changes in the middle ground. Paint the ground cover a different green than the bushes. For the lights in the middle-value ground cover, use warm mixtures of Cadmium Yellow Pale, Cadmium Yellow Light, Ultramarine Blue, Cobalt Blue and a touch of Cadmium Red Light. Use more Cadmium Yellow Pale for the ground cover and more Cadmium Yellow Light for the bushes. Exaggerating color changes that you see will have a more powerful effect than if you invent them.

When painting the middle ground, make sure that the light and shadow stay within the middle-value family. Paint the standing water of the middle ground using Cobalt Blue and white mixed with touches of Quinacridone Red and Cadmium Yellow Pale. (It should be darker and more violet than the sky.) Smooth this stroke with a palette knife, leaving a dark shape in the water as a tree reflection.

7 Paint the Foreground

Paint the sandbars of the foreground lighter than the light on the central mountain, but slightly darker and warmer than the sky. Use a large bristle brush (no. 10 or 12 bright or flat) as this is an open area that doesn't require a lot of detail. For the sandbars, use white and Cadmium Yellow Light, with touches of Cobalt Blue and Quinacridone Red. For the water, a middle value, use a mixture of Cobalt Blue, Quinacridone Red and a touch of Cadmium Yellow Pale and white. (It should not be as violet as the shadow on the central mountain. Its value should be darker than the standing pool of water just above it.) Paint it with broad strokes, allowing some of the darker underpainting to show through. Smooth the water below the sandbar with a palette knife, and indicate shallow water, shifting the color toward green with the addition of Cadmium Yellow Pale and Ultramarine Blue. Darken the waterline of the sandbars with a mixture of Cobalt Blue, Quinacridone Red and white.

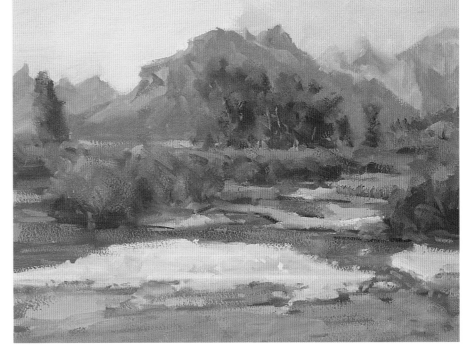

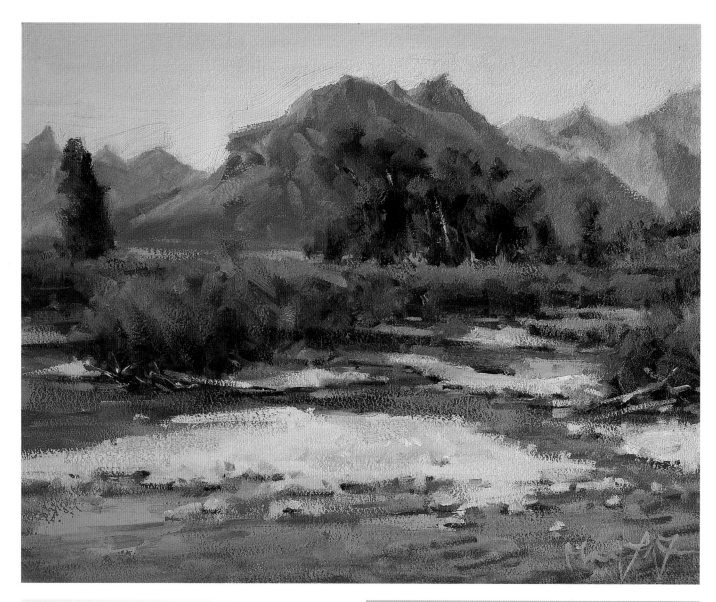

8 Add Finishing Touches

This is the time to stand back and assess. By now, the light has changed significantly. Don't overwork your painting based on a misguided attempt to chase the light, trying to combine different sets of color and value relationships into the same painting. Finish with the least amount of brushstrokes possible. Add a little calligraphy in the middle-ground brush, a few details in the gravel bar and a few strokes of green at the bottom of the water. As your observations become more accurate, you may find that additional details can be more distracting than effective. Working accurately and in tempo (at a pace that keeps up with the changing light) gives your painting a look of spontaneity and a true plein air feeling.

SAINT MARY RIVER,
GLACIER NATIONAL PARK
Oil on panel
12" × 16" (30cm × 41cm)

THE DANGERS OF OVERWORKING YOUR PAINTING

Overworking your painting will result in muddy, lifeless colors, but that is the effect and not the cause. An overworked painting is a reflection of a confused mind and a wavering intent. Uncertainty leads to mindless stroking, or licking, of the painting. If you find yourself painting with no firm intent, stand back, take a moment to reassess and get back on track. Only resume painting when each brushstroke has a specific purpose (lightening or darkening an area, changing a color, and so on).

Winter Willows

Painting a Snow-covered Stream Surrounded by Willows

This oil was painted in southern Colorado, along the Rio Conejos. The winter color harmonies of the Southwest are among the most beautiful I have ever painted. In winter, the willows drop their leaves and the branches take on beautiful shades of red, a very beautiful and elusive color. Add to that the warm gray of the cottonwoods, white snow and blue sky, and it makes a particularly colorful landscape.

This piece was painted on a beautiful winter day. Sizing up the situation, the conditions were favorable. The winds were low to moderate, it was unseasonably warm and the working time was adequate. In other words, it was perfect!

MATERIALS

Paint
- Utrecht Oils
 Cadmium Yellow Pale
 Cadmium Yellow Light
 Cadmium Red Light
 Ultramarine Blue
 Cobalt Blue
 Titanium White
- Grumbacher Oil
 Quinacridone Red

Brushes
- Nos. 4, 6, 8 filberts
- Nos. 10, 12 flats
- Nos. 6, 10, 12 brights
- Nos. 6, 10 rounds
- No. 8 sable round

Painting Surface
- 12" x 16" (30cm x 41cm) panel of Red

Lion canvas mounted to ⅛" (3mm) mahogany plywood

Other
- Pencil
- Sketch paper
- Mineral spirits

WINTER PAINTING

One of the most difficult logistical problems of painting in the winter is avoiding cold feet. Cold feet can negatively affect one's concentration quicker than just about anything. Wool socks and a good pair of winter boots are essential. Also consider bringing a carpet remnant to stand on. Having a barrier between your boots and the cold ground is a great, simple solution.

1 Start With a Preliminary Sketch

Start with a five-minute sketch to work out your composition and get your painting off to a good start. The value pattern for this piece should be simple. The snow will help to create large shapes of clearly separated values. The challenge will be more in re-creating the nuances of light than in organizing the values.

2 Block In the Main Elements

Using oil paint thinned with mineral spirits, make a drawing placing the elements within the composition. Wash in the willows with mixtures of Quinacridone Red, Cadmium Red Light, Cadmium Yellow Light and white, along with a touch of Cobalt Blue. Color changes include darkening the bottom and adding some cool red to the left. Wash in the piece of snow warmed by sunlight (left of willows) using Cadmium Yellow Light, white and a touch of Quinacridone Red. This is the lightest and warmest piece of snow, and it will be useful to compare it against other passages.

3 Continue Blocking In

The cottonwoods, along with the willows, are part of a larger, middle-value shape. Wash them in with Cadmium Red Light, Cadmium Yellow Light, white and Ultramarine Blue. Keep the edges soft. Use the same pigments to add a dark to the left of the willows and some green (Ultramarine Blue and Cadmium Yellow Light) below that. Paint the distant hill (above the cottonwoods) with Ultramarine Blue and Cadmium Yellow Light, with touches of white and Quinacridone Red. Begin the sky with a wash of Ultramarine Blue and white, mixed with touches of Cadmium Yellow Pale and Quinacridone Red.

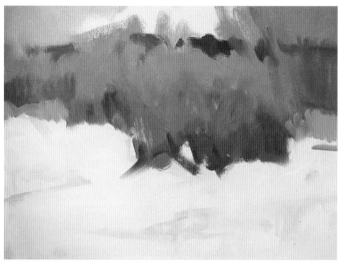

4 Add the Snow, River and Shadows

The bottom half of the painting is the most complex part, with subtle color and value changes. Wash in the snow under the willows with cool mixtures of Cobalt Blue, white and touches of Quinacridone Red and Cadmium Yellow Pale, comparing it against the warmth of the snow at center-left. Using Ultramarine Blue, Cadmium Yellow Pale and a touch of Quinacridone Red, paint the river on the left edge of the canvas. Keep it darker and more violet than the water near the bottom, which is lighter and uses more Cadmium Yellow Light. Paint the snow shadows with a violet cast using Cobalt Blue and Quinacridone Red, with touches of Cadmium Yellow Pale and white. The long shadows in the middle-left are bluer, and the ones below the willows are redder. Finally, soften the edges (at the bottom) between the snow and the water.

5 Paint the Background

The blue of the sky has a slight red shift. Use Ultramarine Blue, white and touches of Quinacridone Red and Cadmium Yellow Pale. Pull the wet paint of the sky down into the trees and against the distant hill. Paint the hill using the same colors as the underpainting, unthinned. Soften the edges. For the lights on the cottonwoods, mix Ultramarine Blue, Cadmium Red Light, white and a touch of Cadmium Yellow Light. Soften the edges between the trees, distant mountain and sky. Keep the calligraphy of the tree trunks simple, making sure the value isn't too dark. Keep the lights of the branches darker than the snow. Remember that this area of the painting is a supporting player in the drama. Hold off judgment on how finished it looks until more of the painting is complete.

6 Add the Winter Willows

Using mixtures of Quinacridone Red, Cadmium Yellow Light, Cadmium Red Light and a touch of white and Cobalt Blue, restate the ground-level darks of the willows with thicker paint. Use vertical brushstrokes to emphasize their texture. Keep the calligraphy simple (so the large shape remains intact) and the edges soft. Darken the distant willows (at center-left) using the same pigments as used to initially paint them. For the grass pushing through the snow, use Cadmium Yellow Light, a touch of Quinacridone Red and Ultramarine Blue, and white. Add shadows by painting some neutral gray on the ground beneath the trees. Soften these edges and keep their values in the middle range.

7 Paint the Snow

Paint the warm area of snow (left of the willows) with impasto brushstrokes using white and Cadmium Yellow Light with just a touch of Quinacridone Red. Establish this area as the lightest and warmest passage. Slightly cool the snow above the long shadow with a touch of Cobalt Blue. Paint the snow below the willows darker and more violet by adding Cobalt Blue and Quinacridone Red. Lighten that snow shape as it moves from right to left. Compare each section of snow to its neighbors until they are accurately adjusted. Finally, with a small filbert, paint the dark lines at water level using Ultramarine Blue, Cadmium Yellow Pale and Quinacridone Red. Add some calligraphy of land sticking up through the snow using a mixture of Ultramarine Blue, Cadmium Yellow Light, Cadmium Red Light and white.

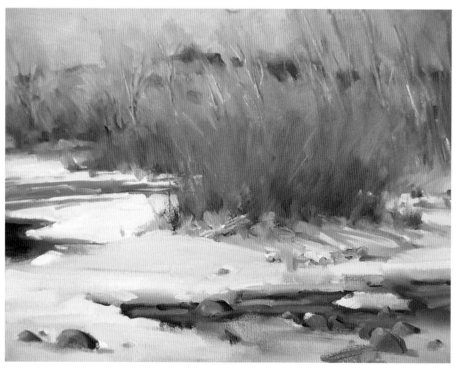

8 Finish the Foreground

The values of the snow and ice are determined by their depth. Where the ice is very thin, the value is darker, and where the snow is deeper, the value is lighter. Using mixtures of white, Ultramarine Blue, touches of Quinacridone Red and Cadmium Yellow Pale, and a no. 12 bristle brush, darken and cool the snow in the lower-left foreground. (Remember, the fewer the brushstrokes the better.)

Paint the rocks with cool, middle-value mixtures of Ultramarine Blue and Cadmium Red Light with a touch of Cadmium Yellow Light and white, using both a no. 10 or 12 brush and palette knife. Add some warm highlights to the snow (not as warm or light as the snow in open sunlight). Darken the piece of open water on the left with Ultramarine Blue, Quinacridone Red and a touch of Cadmium Yellow Pale. Squinting it down, you will notice that this is the darkest piece of the landscape. Normally, I minimize such a dark shape when it occurs on the edge of the canvas. In this case, it will work as a counterpoint to balance the dominant hot-red shape of the winter willows.

9 Add the Finishing Touches

When a plein air painting is looking good, the finishing touches should be held to a minimum. Add a few middle-value brushstrokes of blue-violet (Ultramarine Blue, Quinacridone Red, Cadmium Yellow Pale and a touch of white) into the base of the willows and paint a few sky holes between the branches. (Do this judiciously; it's so easy to overwork it!) The little island of snow in the bottom right should be subdued, keeping the focus where it belongs. If the relationships between the elements of this painting seem accurate, don't snatch defeat from the jaws of victory by overworking it in this final stage.

WINTER WILLOWS
Oil on panel
12″ × 16″ (30cm × 41cm)
Private collection of David L. Bauer

Grosvenor Arch

Painting a Sun-drenched Rock Formation on a Windy Spring Day

This oil was painted in the Grand Staircase-Escalante National Monument in south-central Utah. The region has an unusual majestic quality that I find irresistible, from the eroded sandstone to the beautiful and exotic color harmonies of the desert. The canyon country of the Southwest is also one of the more difficult subjects I have encountered. Perhaps the difficulty lies in capturing the unique subjective quality of the unusual landscape. Whatever the reason, I am convinced that the solution to such problems lies in the act of seeing.

Sizing up the scene, there were two potential problems. First was the wind, which is always a factor during early spring in the high desert. I set up my full-size French easel/Easel Pal next to a large juniper tree, hunkering down against the wind and getting a bit of shade in the process. This windbreak also allowed me to use my clip-on white umbrella. The second potential pitfall was the rapidly changing light.

Anytime there is a dramatic cast shadow, you can count on the light changing too fast. In such cases, be prepared to move along at a decent clip.

MATERIALS

Paint
- Utrecht Oils
 Cadmium Yellow Pale
 Cadmium Yellow Light
 Cadmium Red Light
 Ultramarine Blue
 Cerulean Blue
 Titanium White
- Grumbacher Oil
 Quinacridone Red

Brushes
- Nos. 4, 6, 8 filberts
- No. 12 flat
- Nos. 6, 10, 12 brights
- Nos. 6, 10 rounds
- No. 8 sable round

Painting Surface
- 12" x 16" (30cm x 41cm) panel of Red Lion canvas mounted

to ⅛" (3mm) mahogany plywood

Other
- Pencil
- Sketch paper
- Clip-on umbrella

SPEED OF EXECUTION

Changing light and shifting color and value relationships make the ability to work quickly a valuable skill. The trick is to work within the context of accuracy (rather than fast yet wrong). Practice working quickly on a small scale to start, keeping in mind the goal of accuracy.

1 Create a Preliminary Sketch
Light and shadow enhance the value pattern in this piece, creating interesting forms. Here, there are a few clouds, a possible threatening situation if the sunlight is cut off midway through the painting. Therefore, this value sketch is even more critical. Take several moments to create your value sketch, nailing down the shadows and large shapes of connecting middle values.

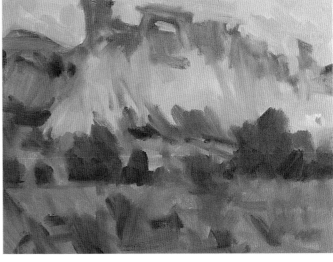

2 Begin the Block-in

Start with a brush drawing, placing the large shapes on the panel. Wash in the arch with light-value mixtures of Cadmium Yellow Light, Quinacridone Red, white and a touch of Ultramarine Blue. Darken the top of the arch with the same colors. For the foreground, wash in a middle-value of Cerulean Blue, Cadmium Yellow Pale, white and a touch of Quinacridone Red. Start the distant hill with the same colors, but allow the warmer hues to dominate. You should have a clear separation between the big shapes of light and middle values.

3 Complete the Block-in

Wash in the sky with Cerulean Blue, white and a touch of Quinacridone Red and Cadmium Yellow Pale. Wash in the clouds using a large, clean bristle brush and warm colors, including Cadmium Yellow Light, Quinacridone Red and white. Paint the darker juniper trees using Ultramarine Blue, Cadmium Yellow Light and a touch of Quinacridone Red. Keep the close tree line warmer than the trees in the distance. Add a warm ground tone using a mixture of Cadmium Red Light, Cadmium Yellow Light and a touch of Cerulean Blue. Block in the arch using darker tones (Cadmium Red Light, Cadmium Yellow Light and touches of Cerulean Blue and white). Soften the edge between the sky and the arch.

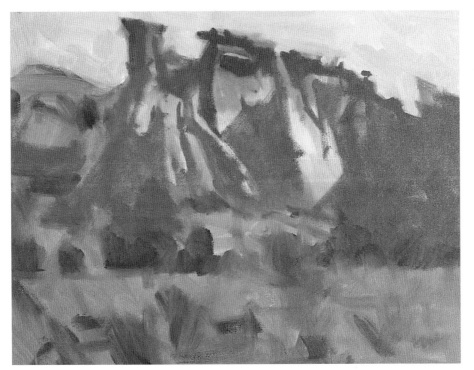

4 Begin Rendering the Arch

Grosvenor Arch is a fairly complex form, and the key to rendering it is simplicity. Paint the middle-value shadow using a mixture of Cadmium Yellow Light, Cadmium Red Light and a touch of Cerulean Blue and white, keeping the shadow cooler at the top (a little more Cerulean) and warmer at the ground (a little more of both Cadmium Yellow Light and Cadmium Red Light). Hold the value while changing the color. (Too many value changes within a shadow will compromise its form.) Think of the shadow as one big, interlocking shape. Add a warm green (Ultramarine Blue, Cadmium Yellow Light and touches of Quinacridone Red and white) to the top of the trees and soften the edges between the trees and shadow.

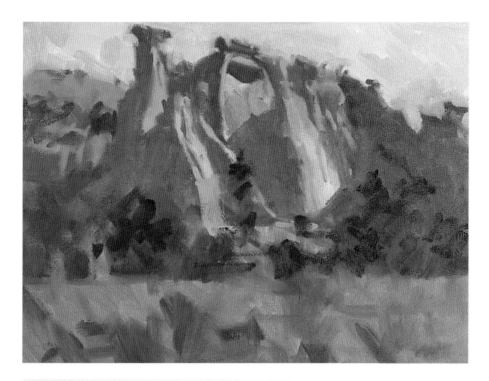

5 Paint the Subtle Changes in Light and Shadow

Create a number of very subtle color changes on the arch. Cool the shadow on the left edge (between light and shadow), the cast shadow (in mid-center) and on the right using Cerulean Blue, with touches of white, Quinacridone Red and Cadmium Yellow Pale. (Hold the value of the shadow, don't darken it.) Add a light at the top (under the arch) using white and Cadmium Yellow Light, with touches of Quinacridone Red and Cerulean Blue. Darken that light as it moves down the sandstone. Using Ultramarine Blue, Cadmium Yellow Light and touches of Cadmium Red Light and white, paint the dark of the trees, a value which is now easy to judge when compared against the middle value of the arch's shadow. Keep the edges soft.

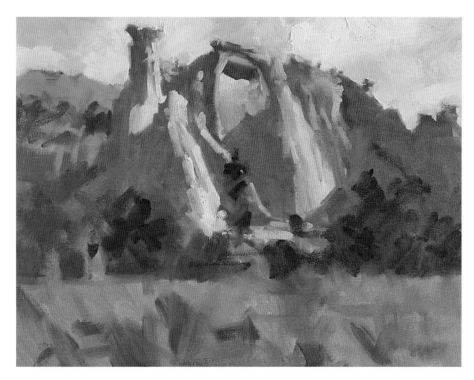

6 Add Details

With the light effect coming into focus, begin to add texture by applying thicker paint, starting with the sky. Judge the color and value of the clouds against the light on the arch. Both colors should be warm (Cadmium Yellow Light, white and touches of Quinacridone Red and Cerulean Blue), however, the light of the arch should be a note lighter than the clouds. Paint the arch's lights using mixtures of impasto paint. Add some color changes in the transitional values, as the form turns from light to shadow, using the same pigments as the block-in, but with less white. Paint the ground slightly darker than the lights of the arch. Work with confidence, relying on the accuracy of your earlier decisions. In other words, state it.

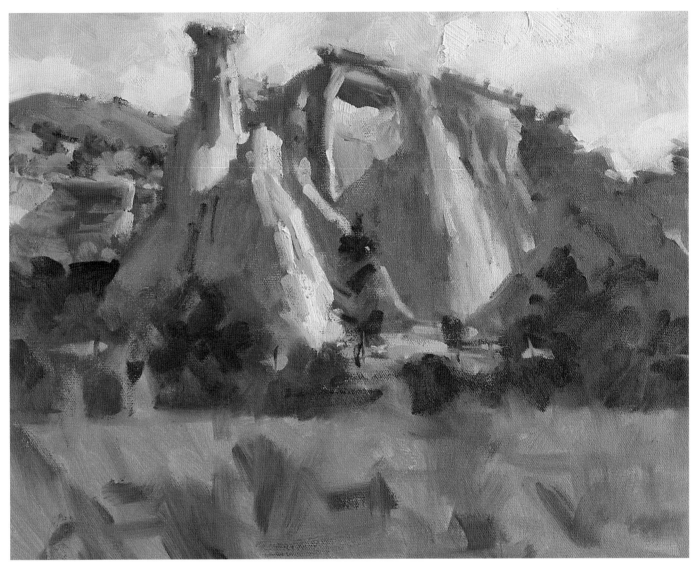

7 Finish the Arch

Finish the right portion of the arch and add a few dark accents (Ultramarine Blue, Cadmium Red Light and touches of Cadmium Yellow Light and white) within the arch itself. (These dark accents must remain in the middle-value family.) Begin the distant hill on the left using mixtures of Cadmium Red Light, Cadmium Yellow Light and touches of Cerulean Blue and white. Judge the lights of the hills, tree and cliff by comparing them to the light of the arch. (They should be darker and more neutral.) Keep the forms simple and the edges soft. Paint the dark accent at the lower left behind the arch using Ultramarine Blue, Quinacridone Red and a touch of Cadmium Yellow Light.

Detail
It's fun to find interest in secondary places. Here, the distant hill is an interesting piece of detail and makes a good counterpoint to the arch. Render the changes of color in the limestone (the white band), the pinon pines and the junipers simply.

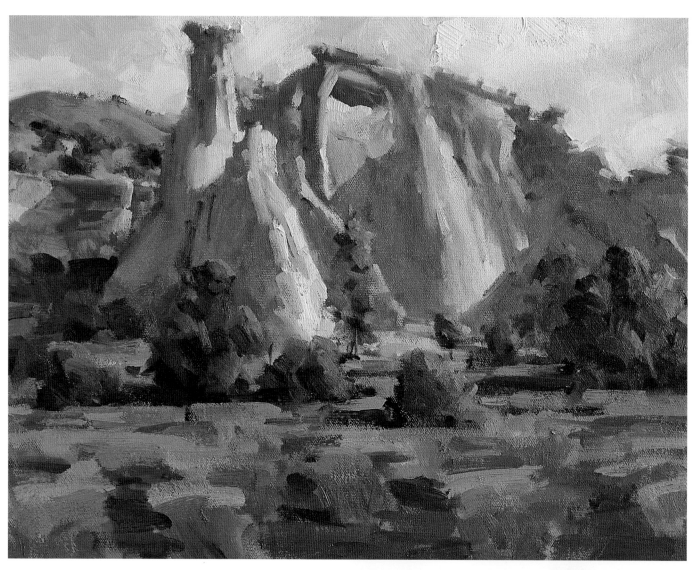

8 Paint the Trees and Foreground

Paint the lights of the middle-ground trees using Cadmium Yellow Light, Ultramarine Blue and a touch of Cadmium Red Light. Judge these lights against the other lights of the painting. Add the cast shadows of the trees on the sagebrush. For the middle value of the sagebrush, use impasto strokes of Cerulean Blue, Cadmium Yellow Pale, white and a touch of Quinacridone Red. Darken the sagebrush (near the ground) with the same pigments, using a little less white. Paint the foreground sand with Cadmium Red Light, Cerulean Blue and a touch of Cadmium Yellow Pale and white.

Detail
Paint the foreground simply. Keep the entire area within the middle-value family so the large middle-value shape will act as a foil for the light-struck arch. Carefully judge the color changes, including the lights and darks of the sagebrush and ground, against the light value of the arch.

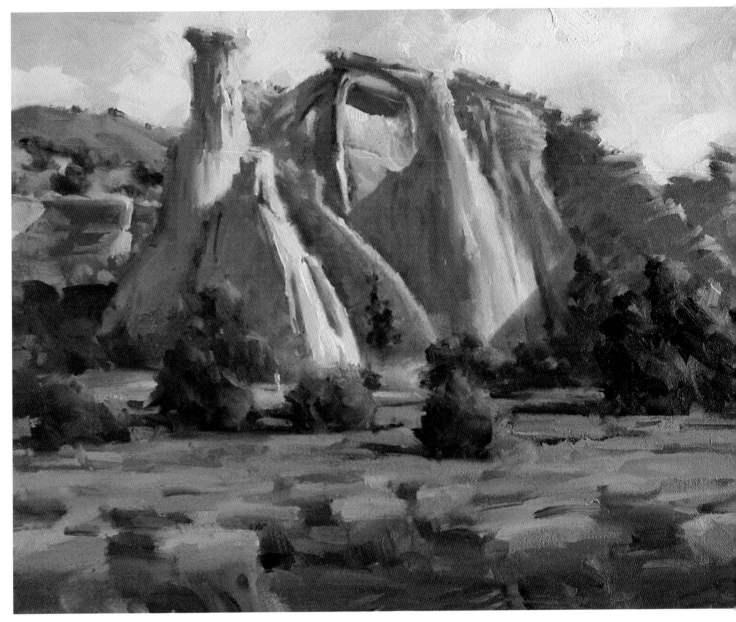

9 Add the Finishing Touches

Add a few lights to the right section of the arch using a lighter value of the same pigments. (These lights should be darker than the lights in the main part of the arch.) Soften the edges of the dark accents within the arch as well as a few edges in the trees and foreground, using a clean brush. (Soften only those edges that don't pull together when you squint it down.) Resist the temptation to overwork your painting at this stage. The final accent is the addition of the figure, which gives scale to the arch. Using a small round sable, paint the figure simply. The addition of the person's shadow and a touch of light is all that's required.

GROSVENOR ARCH
Oil on panel
12" × 16" (30cm × 41cm)

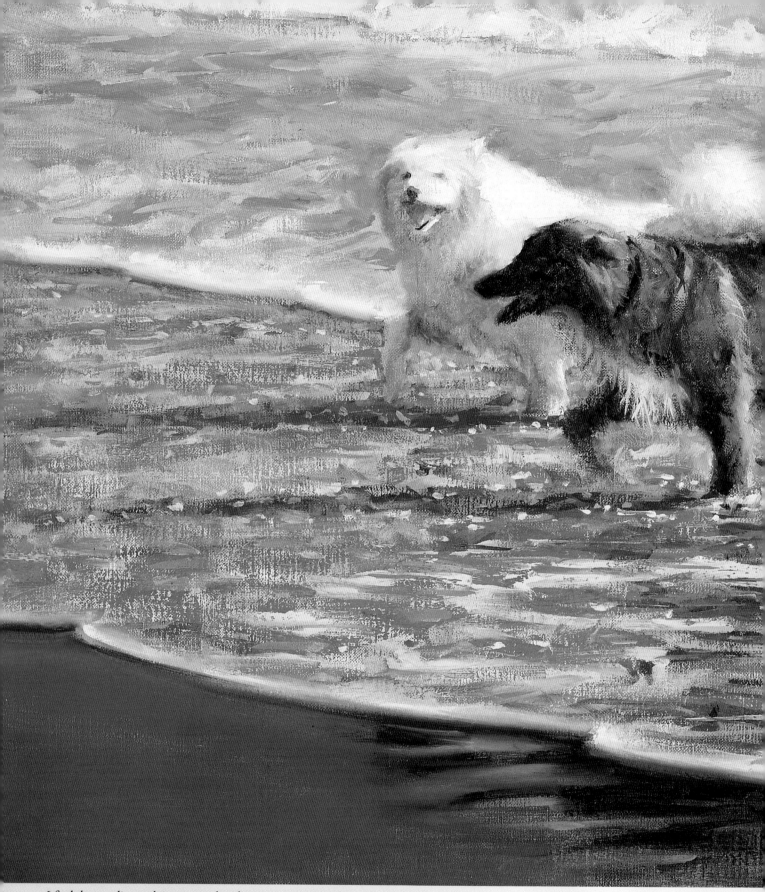

I find that studio work is energized in direct proportion to the effort put into painting on location. This oil was painted in the studio using a slide shot while on a painting trip in northern California. It comes alive in a way only possible from a strong plein air experience. On this trip alone, I logged over sixty hours of direct observation on the coast.

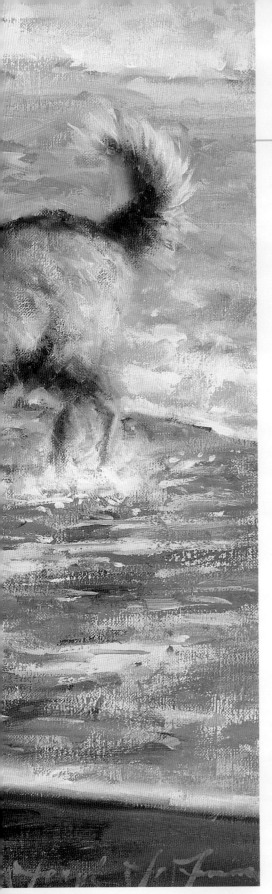

USING PLEIN AIR
WORK IN THE STUDIO

The relationship between plein air painting and studio work is fascinating. The artist's ability to visually comprehend a subject is the beginning of everything. Since painting from life teaches us how to see, it is really the foundation on which studio work is built. If you return from a painting trip with ten paintings, and each one took two hours to paint, then rest assured that those twenty hours of direct observation are more valuable (in the long run) than the paintings themselves. This is especially true if a studio series is intended. The plein air experience will make your reference material come alive. Even more important, you will have something to say in the work, a direct response to your subject that can be lacking when the only effort is to focus a camera and click.

THE DOG DAYS OF SUMMER
Oil on canvas
20" × 24" (51cm × 61cm)

Studio vs. Plein Air Painting

Studio painting has a fundamentally different set of challenges and usually produces work with a higher degree of finish. When working in the field, you will be faced with constantly changing light, creating a natural tempo in the painting process. In the studio, there is no such requirement. Breaking for lunch is possible without missing a beat. The more relaxed climate is conducive to a closer look at the smaller wonders of what you are seeing.

The benefit of plein air work is still present, but more subtle. A strong painting is dependent on an accurate set of color and value relationships, no matter what the degree of finish. It's a challenge to hold onto these big picture relationships while painting in greater detail.

Another goal for studio painting is to bring the quality of plein air work indoors. It's a challenge to get the same passion and immediacy into studio paintings that fieldwork seems to have almost by definition. Making work that is painted from reference material appear as if it were directly observed is not easy. It is the art that conceals art.

Painting in your studio can be a dynamic experience, a veritable cauldron of creativity where ideas are explored, techniques tried and new ground broken. It should never be seen as a place to hide from the hassles of working outdoors. Rather, it provides you with the opportunity to explore the depth of your creativity, a supplement to painting from life that will deepen the experience of working in the field.

RESIST TEMPTATION

There is always a temptation to overdevelop a painting in the studio. Try to resist that urge by staying focused on a clearly defined goal.

One of the best uses of photographic references is for subjects that are difficult or impossible to paint directly from life. This watercolor was painted in the studio after a trip to Mexico during Easter week. The women, dressed in their colorful best and with children in tow, were in constant motion. In addition to taking the photograph used for this watercolor, I painted quarter-sheet watercolors on-site. I wanted this watercolor, a character study of an Indian child, as fresh and simple as if it were being observed directly.

INDIAN MADONNA
Watercolor on Arches 140-lb.
(300gsm) cold-press paper
15″ × 22″ (38cm × 56cm)

Painting From Slides and Photographs

Undoubtedly the most common studio practice is using photographs as reference material. One thing you will learn is how inadequate even the best photographs really are. Because the subtleties of light don't come through in photography, you will need to make some corrections when working from photographic references. The more time spent on-site in a particular location, the easier this is to do.

You will also find that squinting down photographs doesn't work. You need to find out for yourself what's missing from a photograph, and you do that by directly observing the effects of light. Once you have built a reservoir of experience, you'll be able to tap into that well of knowledge and make the appropriate adjustments to slides and photographs in doubt.

In the beginning, try this. If you suspect that a shadow in your photograph is inaccurate or isn't showing enough information to paint it, go outside and find a similar shadow to observe. It probably won't offer the same conditions, but the difference between the observed shadow and the photograph will nevertheless be a revelation. Remember: Photography is a more useful tool if it's not taken literally.

Another great benefit in painting from life (and not relying too heavily on photo references) is that, over time, your work will take on a greater expressive quality. However, expressive paintings require something to express — a direct experience that is heightened by being there and doing it.

When working in your studio, strive to bring a plein air look indoors. Use photographic references as if you are painting on location. First, start with a pencil thumbnail sketch to organize, simplify and compose the material. Then approach the painting process in a similar manner. While there may be a natural slowing in the pace at which you are working, there should be no change of attitude. Every brushstroke is significant, and nothing is done without purpose. The greatest danger is in overworking the painting; not only in the sense of turning it into mud, but also of losing that direct, observed quality present in outdoor work. Blending the two modes of working is a conscious decision, and you need to maintain that awareness throughout the entire painting process. The challenge is to get your studio paintings pumped up with the same energy inherent to plein air painting.

This piece was also a studio-only opportunity. While in Montana, I saw this family of bears on a distant hillside. I made several drawings with the aid of a pair of binoculars and shot some slides using a telephoto lens. While the slides weren't great, the combination of slides and drawings provided me with enough raw material to work with in the studio.

ONCE UPON A TIME
Oil on canvas
20″ × 24″ (51cm × 61cm)

Combining Elements of Slides Into One Painting

When I get slides back from a painting trip, I am almost always disappointed. Not because of poor exposures or the quality of the slides themselves; rather, the slides are not as interesting, colorful or memorable as I remember the experience to be. They never evoke the same strong response that being there did. Direct experience is always more intense than a description of it.

A studio technique that I enjoy using to compensate for this loss is to combine elements of different slides into one painting. *Watermelon Mama* was composed in this manner; I re-created my impression of the subject. It's like painting from memory, but with a crutch.

As an artist, your impressions are more precious than reality. For artistic purposes, they are more real. Use your photographic references to reconstruct an impression. If your reference material doesn't align 100 percent with your memory, arrange and rearrange the elements until they do. When there is conflict between your references and your memory, always reserve the final veto power for yourself. What you have to say or express in a given painting is more clearly contained in that memory than in the details of the scene.

Reference photography can be a studio asset, but it should not be taken too literally. I find photography most useful when drawing. This composition was pieced together from a few slides and a photo, and was orchestrated to achieve what you see at right. Use caution when relying on photos for the subtle relationships of color and value between the different elements of your painting.

WATERMELON MAMA
Oil on canvas
30" × 40" (76cm × 102cm)
Private collection

Reference Slides

Reference Photo

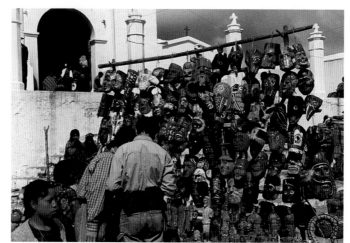

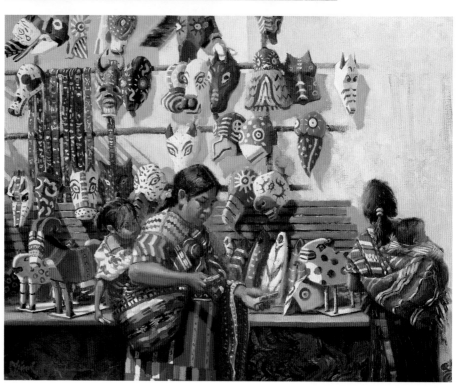

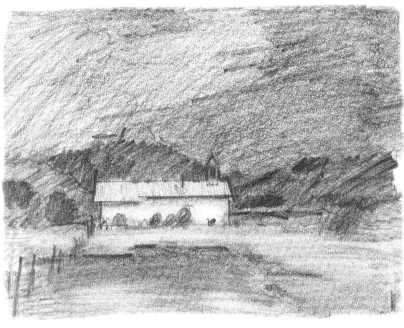

Preliminary Sketch

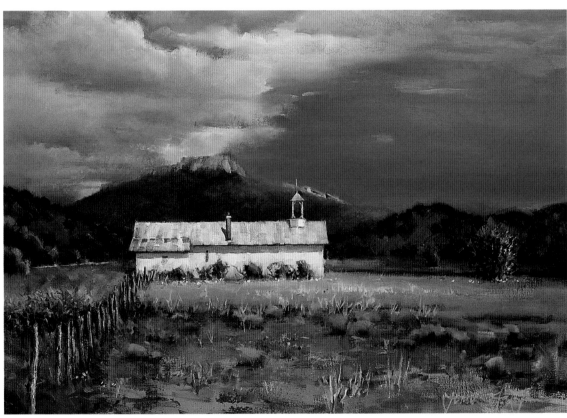

SUMMER RAIN TRINIDAD, COLORADO
Oil on canvas
22″ × 28″
(56cm × 71cm)
Private collection

This oil was painted in the studio immediately following a summer painting trip in southern Colorado. I painted this old adobe church a few times, as well as the landscape around it. Back in the studio, the impression of this trip was still very vivid. The summer monsoons had created very dramatic effects, including an occasional sunburst that would break through the stormy sky and last for a very short time. This painting was constructed out of those elements: a stormy sky, the old church, the distant mountain and the foreground.

The effect of the finished piece fits my memory perfectly. In fact, it is uncanny how much this painting feels like that painting trip. The fact that this particular view doesn't really exist is incidental. Studio painting is a good time to take some expressive liberties with your art.

Using Field Sketches for Studio Work

One of the more fascinating applications of fieldwork is using your sketches as the basis for larger work. This takes faith in yourself and confidence in your observations. Every last tone doesn't have to be perfect in order to succeed on a larger scale. The road map for the larger work is the relationships of color and value between the various elements of the painting. As long as these relationships are accurate, the painting will work.

Through trial and error, you learn very quickly what is important and what isn't. Each time you use a field sketch to make a larger painting, and in doing so learn what you missed while on location, you can fine-tune your next set of observations to include those important missing elements. In time you will close the loop on what has been visually eluding you.

Field sketches are also useful when producing large-scale works. For example, you can use an 8″ × 10″ (20cm × 25cm) field study to make a 36″ × 48″ (91cm × 122cm) oil. One small brushstroke can translate into an area larger than the whole panel. On a small panel, a foreground may be completed with a few brushstrokes. On a larger canvas, similar handling may not work as well. There is usually the temptation to embellish a larger area with more drawing and greater detail, which may not be present in the sketch.

Grappling with problems of scale is an excellent way to learn about painting. The challenges of scale do not change the fundamental importance of properly aligning the relationships of color and value between the painting's elements.

There can be a danger in using photography for color reference, at least in combination with a sketch. The two color harmonies (of the plein air sketch and the slide) may leave you confused. If you start picking and choosing between the two, you could end up in a no-man's-land of confused relationships.

NAVAJO SANDSTONE

This on-location study, painted in oil, was later used to create the finished piece at right.

STUDY FOR NAVAJO
SANDSTONE
Oil on panel, 12″ × 10″ (30cm × 25cm)

You will get the greatest benefit by sticking to your own color observations.

While referring to your reference slides and photos can help to resolve drawing problems, try to resist doing so unless absolutely necessary. Maybe it's psychological, but referring to a slide in the middle of a painting seems to break the spell and taint the process.

Your goal should be for the slides to become unnecessary once you have begun your painting. This, in turn, is great incentive to bring home even more information in the next plein air sketch. This practice can unite your studio and outdoor painting experience into a seamless whole, with each supporting the other.

The on-location piece (at left) isn't a bad painting, but it doesn't capture the subjective quality I felt in East Zion, Utah. I recomposed the study in my studio, simplifying it considerably. There are still many similarities between the two: the center of interest in both is the blind arch, and both have an electric-blue sky. The main difference is that the studio piece was reconfigured for the purpose of expressing a particular response to the unique landscape.

NAVAJO SANDSTONE
Oil on canvas
20″ × 16″ (51cm × 41cm)

BOULDER MOUNTAIN

① The Ranch at Boulder Mountain *is a good example of a large-scale work made from a plein air sketch. The field sketch was quickly made on a cold winter afternoon in Boulder, Utah. I didn't even finish the sketch due to a near-hypothermic condition setting in. But the beautiful winter color harmony was already established, and this was the basis for the studio oil.*

② Photographic references were used to help design and add a center of interest to the larger oil. Since Boulder is a ranching area, I used elements that were already present.

③ This 11″ × 15″ (28cm × 38cm) watercolor served as a study for the cowboy and the two cows. I wanted to keep these elements simple, and the best way to accomplish that is to have a working knowledge and understanding of the forms. The figures provide scale for the mountain landscape as well as showing local color. Adding such accents and embellishments to studio versions of outdoor sketches can make a perfect finishing touch.

RIGHT
④ The end result of combining a preliminary sketch and reference photos, along with a watercolor of the cowboy and cows, is this finished piece. Although the gestures of the man and cows may be somewhat altered from the original photos, the references provided a point from which to start. The watercolor study helped to address drawing the figure group as well as the light effect.

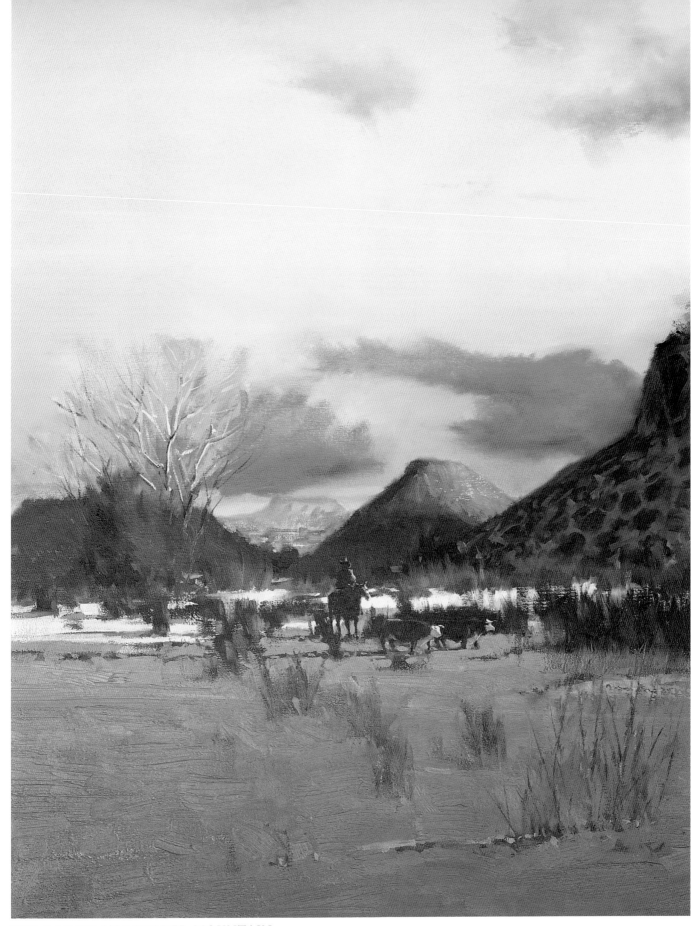

THE RANCH AT BOULDER MOUNTAIN
Oil on canvas
30″ × 40″ (76cm × 102cm)

Study for Down East *was painted on the coast of Maine from the same painting trip and series as the watercolor* In the Bait House of a Maine Lobsterman *(page 27). The sketch was used a few months later in the studio for painting the full-sheet* Down East.

STUDY FOR DOWN EAST

Watercolor on Aquabee Super Deluxe
sketchbook paper
12″ × 9″ (30cm × 23cm)

As you can see, I made a number of changes to my study, most notably in the composition. ① *The decoys of the butterbill coots were moved over a bit,* ② *the foreground was lengthened, and* ③ *the yellow buoys were removed from the left side of the sketch.* ④ *The watercolor was also keyed up a bit as the atmospheric quality was a little compromised due to the overall darkness of the sketch. These adjustments are arbitrary. Each plein air sketch contains worlds of possibilities. The sketch represents the hard work: the variations roll off effortlessly and are great fun!*

DOWN EAST

Watercolor on Fabriano Esportazione
147-lb. (313gsm) paper
30″ × 22″ (76cm × 56cm)
Private collection of Suzanne and Bernie Lyons

Painting From Memory

Painting from memory is an art within an art. It is a very pure and personal means of expression. What is held in memory is the distilled essence of an experience. It is not necessary to remember all of the extraneous details. In fact, that can be counterproductive. When working from memory, the artist is required to use all of the learned skills of drawing, composition, color and value control, but they are put in the service of a different master.

I remember a conversation with Millard Sheets, a late artist and friend, many years ago in his studio. I was fascinated by the originality of his work, and it was a revelation to hear him speak of the importance of memory in the context of self-expression. Millard graciously humored me through what must have been a series of dumb questions, and I really didn't get what he was saying until I saw some of his sketchbooks from a trip to Africa. The information recorded in these sketchbooks caught me completely off-guard. I was expecting elegant drawings. Quite to the contrary, the sketchbooks weren't even visually oriented. They just recorded information, things that caught his eye. This master artist weaved his web of magic by shining his life-experiences through the prism of accumulated skills in designing, drawing and using color. Memory focused it. He was dismissive of the value of a camera, "a hindrance," he called it, if I remember correctly.

My own experience of painting from memory has evolved over the years. For the most part, I have also relied on sketchbooks, both store

This watercolor was painted in Antigua, Guatemala, during their world-famous Lent ceremonies. Painting it was quite a challenge, with surging crowds and swirling motion everywhere. It was a perfect opportunity for memory work. With sketchbook in hand, I positioned myself about fifty feet in front of the religious procession and started drawing directly on the watercolor paper. When the procession had cut the distance in half, I quickly retreated, reestablishing a distance between myself and the procession, and continued working, the whole time dodging and getting jostled by large crowds. I kept at it until the procession ended. With three or four drawings in hand, I immediately returned to my hotel room to paint. The memory was very strong and vivid. It was almost like painting the scene from life. Sometimes conditions require improvisation. Just make it up as you go along.

VIA DOLOROSA
Watercolor on Fabriano Esportazione 90-lb. (190gsm) paper
15" × 11" (38cm × 28cm)

bought and my own (pages 17–18). Hot-press watercolor paper makes a particularly nice drawing surface.

I have developed a personal shorthand, a code that enables me to record color and value information quickly. Symbols, such as *CB* for Cobalt Blue, *Wm* for warm, and numbers, such as *1* for the lightest value, *2* for the middle and *3* for the darkest, allow for quick recording of information. For example, a cool middle-value gray, such as Viridian mixed with Cadmium Red Light, would be noted as *V/CRL/2*. (I have lost a few gallery sales when potential clients noticed a code or two lurking under the washes. Usually I erase my codes before painting, but sometimes I forget.) In spite of creating the drawings from life, there is still a heavy reliance on memory. The notations are only intended to jog your memory. Your coded drawings will prove to be most effective when used immediately.

Even a week later, your memory may significantly diminish. Six months later, such drawings will be useless for capturing specific impressions.

It's very gratifying to pull off a painting that could not have been done any other way. (Both *Via Dolorosa* and *Sol Latino* were painted using shorthand notations.) Painting from memory is an excellent way to train the eye, as well as to introduce a depth to your work that can be difficult to achieve otherwise.

A FINAL NOTE ON NOTES

You will find that if the painting is done immediately, you won't need notes on colors and values. However, if there is a delay between drawing and painting, then notations will prove handy. (After four or five days, the painting of the sketch becomes much more difficult as the memory fades.) Notations will remind you of what it was about the scene that you responded to as well as the colors and values. You could fake it and invent the color harmony, but that would defeat the purpose. The goal is to express a particular experience, not a generic one. So go ahead and create your own coding system.

WHEN TRAVELING, ALWAYS CARRY A PENLIGHT

I always carry a penlight, which is a small flashlight the size of a pencil or pen, when traveling. It uses one AAA battery, takes up very little space and comes in handy for drawing at night or in dark places, such as church interiors, palaces or any number of interesting locations.

This watercolor of the band "Sol Latino" was painted from memory in Antigua, Guatemala. They performed in the main plaza, and I would often go down to hear them play during my month's stay in Antigua.

I used the available light, plus a penlight, to create a drawing in my watercolor sketchbook while at the plaza, making certain to include notations on colors and values. I completed the watercolor immediately upon returning to my hotel room.

SOL LATINO
Watercolor on Fabriano Esportazione 90-lb. (190gsm) paper
15" × 11" (38cm × 28cm)

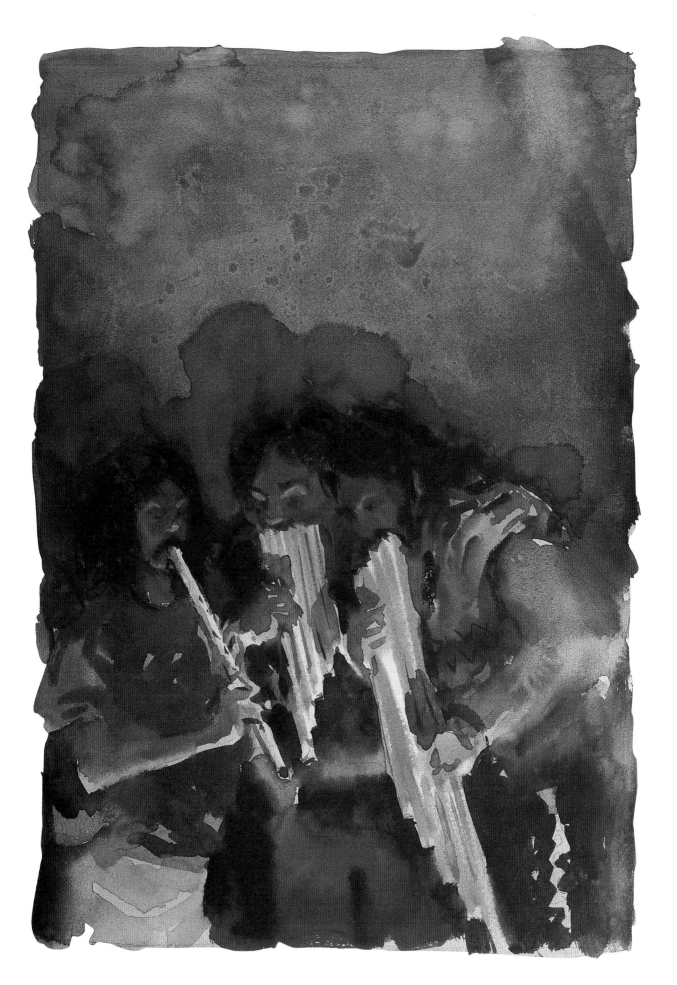

Painting Watercolors From Oils & Oils From Watercolors

Working in two mediums is beneficial in many ways. Painting techniques can be applied back and forth in a cross-fertilization of ideas. This will lead to more confident and spontaneous technique in both, and can be achieved in two ways. First, techniques from one medium can be applied to another. For example, ① try using white paint to make more opaque watercolors. ② Paint oils using an oil-wash technique. ③ Work from dark to light in watercolor, or paint from light to dark with oils. ④ Paint directly on your canvas without an underpainting. ⑤ Rather than reaching for white paint to lighten an oil color, try using the transparency of the pigment. ⑥ Use a palette knife to apply thick watercolor paint. ⑦ Paint oils with soft (sable) brushes. The possibilities are countless.

The second way is more subjective and subtle. It starts by using a watercolor painting to make an oil, or vice-versa. If selecting a particular medium for a particular subject is intuitive, then doing the opposite is counterintuitive. This will teach you a great deal about the craft of painting. If you use oils to paint watercolors and watercolors to paint oils, ideas that would never have occurred otherwise will present themselves. Trying for an effect already achieved in one medium while using the other will present a new challenge of a different order. Think of it in terms of a theme-and-variation movement in music, with the theme as the subject matter and the variations as watercolor and oil paintings. By adopting new ideas and working in different ways, old limitations will be set aside and new possibilities will emerge.

One of the greatest benefits you will find is that over the years your work will look more like itself and less like that of your teachers and mentors. We all have a song to sing, and working in both oil and watercolor has helped me find mine. Pursue whatever ideas or techniques help you to find your song.

From Oil ...
This oil was painted in afternoon light on the Greek island of Santorini. The paint was layered on rather heavily, the white church being a good excuse to pile on the paint. Later, this oil was used to create a series of watercolors.

SANTORINI
Oil on canvas
18" × 14" (46cm × 36cm)

... to Watercolor

I have always enjoyed using a watercolor to make an oil painting, and vice versa. It is like literature that has been translated into different languages. While the meaning remains the same, nuances of each language make every version a little different.

The Wine Blue Sea is based on the plein air oil at left. Here with watercolors, the technical issues regarding white were totally different than with oils. It required an interesting contrast in techniques.

For this watercolor, I tried a technique that I almost never employ: using masking fluid (to cover the church and hold the white while painting the atmospheric effect of the Aegean Sea). If you choose to use masking fluid, remember to soften any hard edges it produced before continuing with your painting. You want the effect to blend into the painting and not jump forward in an obvious way.

THE WINE BLUE SEA
*Watercolor on Winsor & Newton
140-lb. (300gsm) cold-press paper
21″ × 12″ (53cm × 30cm)*

MASKING FLUID AND WATERCOLOR

Masking fluid is one of many tricks and techniques commonly used with watercolors. I have never cared for the effects produced by most of these tricks and techniques, primarily because the process of using them can become more prominent than any expression in the painting itself. (If that technique is the first thing seen from across the room, then its use has been counterproductive.)

From Watercolor ...

This watercolor study was painted in the studio using various reference materials, including sketches and a few on-site watercolors. Years later, while considering painting a large oil of the subject, this study was quickly created.

This particular piece has a look different from most of my watercolors. The directness of approach is intriguing, as is the simplicity of the dog's head. You can almost count the number of brushstrokes that make up its face. The simplicity of execution gives the painting a Zen-like quality.

STUDY FOR DENALI
Watercolor on Arches 140-lb.
(300gsm) rough paper
15" × 11" (38cm × 28cm)

... to Oil ...

To see if the same attitude could be crossed over from the watercolor to oil, this study was approached in a similar manner. The dog's face was handled simply, even more so than in the watercolor. It allowed for no mistakes or corrections—a very disciplined attitude toward painting.

The finished study seems to build on the idea of directness and simplicity of execution first used with the watercolor, and it produced an oil painting different from my usual oils.

STUDY FOR DENALI, NO. 2
Oil on canvas
12" × 9" (30cm × 23cm)
Private collection

... to a Finished Piece

From sketches and on-site watercolors to studies in watercolor and oil, this painting demonstrates the benefits of using plein air painting in combination with studio work and the cross-fertilization of ideas between mediums.

SLED DOGS, DENALI
Oil on canvas
20" × 24" (51cm × 61cm)
Private collection

IN THE LI RIVER
VALLEY, CHINA
Oil on canvas
10″ × 8″ (25cm × 20cm)

SUMMER IN
SANTA FE
*Watercolor on
Arches 140-lb.
(300gsm) cold-
press paper*
16" × 20"
(41cm × 51cm)

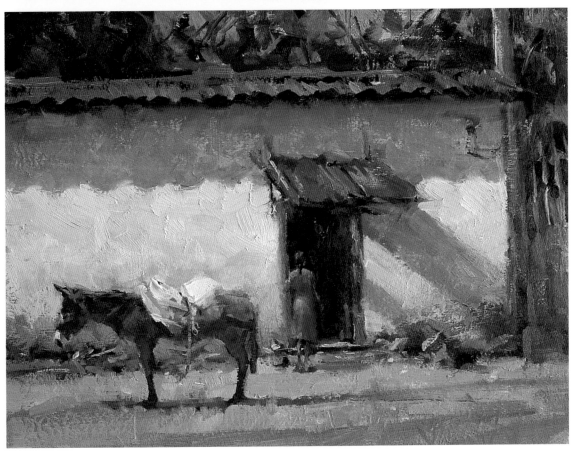

OLD MEXICO
Oil on canvas
9" × 12"
(23cm × 30cm)
Private collection

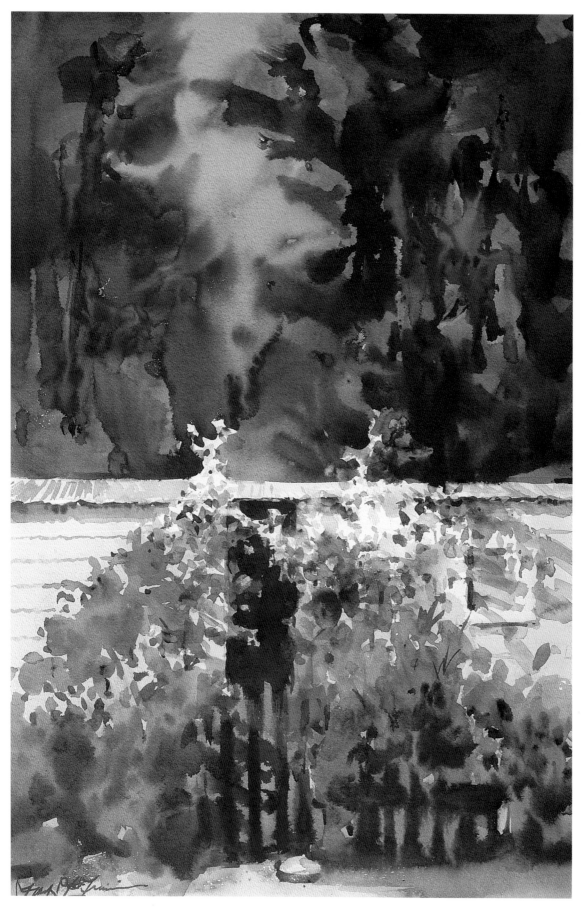

LITTLE HOUSE
IN THE
REDWOODS
*Watercolor on
Arches 140-lb.
(300gsm) cold-
press paper*
*22″ × 15″
(56cm × 38cm)*

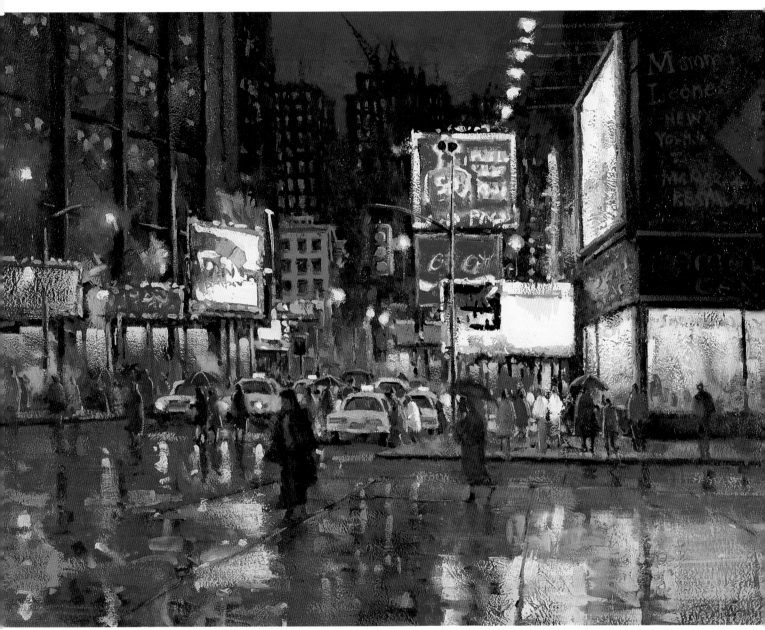

TIMES SQUARE, NEW YORK
Oil on Canvas
30″ × 40″ (76cm × 102cm)
Private collection of Pearle LaLumia

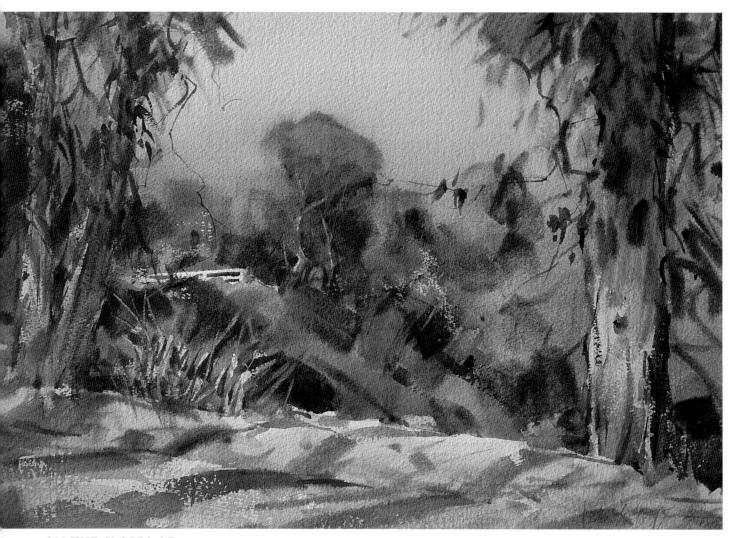

ON THE SLOPES OF
MOUNT ADA
Watercolor on Arches 140-lb.
(300gsm) cold-press paper
15″ × 22″ (38cm × 56cm)

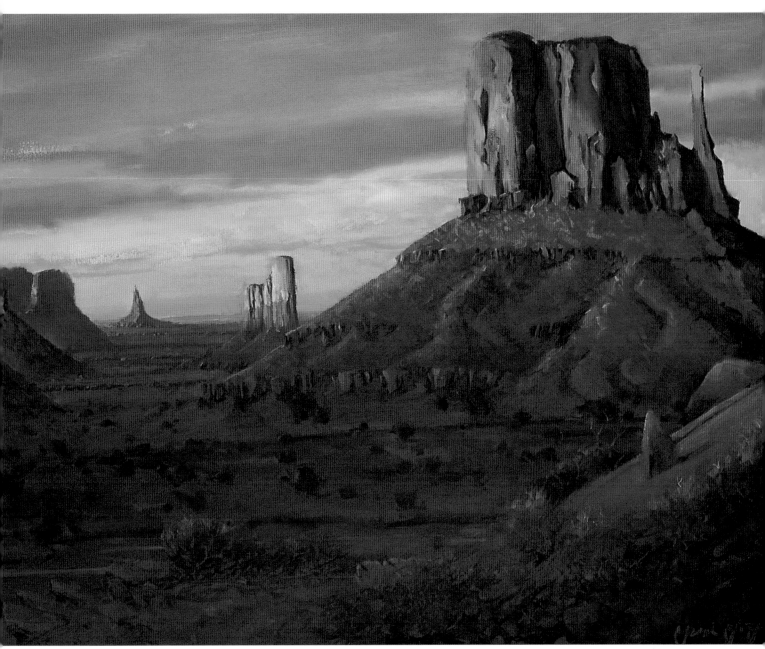

LEGENDS OF THE WEST
Oil on canvas
36" × 48" (91cm × 122cm)

SANTUARIO, CHIMAYO
NEW MEXICO
Watercolor on Fabriano Esportazione
147-lb. (313gsm) cold-press paper
22″ × 30″ (56cm × 76cm)
Private collection of Wendy Marie Teichert

CONCLUSION

The analogy of painting as a language (albeit a nonverbal one) is the best metaphor I know for describing the painter's art. In order to speak any language fluently, it is necessary to have a solid grasp of its grammar, which is the system of rules for speaking and writing. The language of painting has an analogous system of rules that apply to the speaking and writing, or what we call self-expression, in art. The ability to see and comprehend, use color and apply painting techniques in both watercolor and oil are the skills that make up the grammar of painting. Complex thoughts are easier to express in one's mother tongue; it is more difficult to communicate abstract ideas and lofty feelings in a second language that has not yet been fully mastered. And so it is with painting. Study the grammar without losing sight of the fact that the function of the language, art, is to communicate.

The ideas in this book have been aimed at the technique, or the grammar, of painting *en plein air*. The platitude to "paint from the heart" is ineffective when you are stuck in the middle of a difficult struggle. The challenge of organizing and accurately stating each painting is so formidable that you can easily lose sight of the very reason you are painting a particular piece. This difficulty often catapults you, the artist, into a survival mode in which all other considerations fade away except getting through the piece without messing up. We've all been there. Nevertheless, it is a mistake of the highest order.

It is a fine line that separates an artist from a craftsman. Your master class in painting begins when you can hold your focus on something greater than the nuts and bolts of what you are seeing. To quote the great American artist Richard Schmid, from his book *Alla Prima*:

> Your poetic destination must hover over your purely technical efforts like a nagging guardian angel, prodding you to not forget the song you are singing.

Your poetic destination is the *why* of each particular piece. There is a reason that you set up in one place and not another. Something caught your eye, and your ability to hold onto that something throughout the complexity of the painting process is like your diploma; it makes you a true artist regardless of your skill level or experience. Start learning this lesson today. It will give you strength and comfort when you need it most: in the present.

The *how* of each painting is technique-oriented. In this case, the final exam is having enough confidence in your painting technique to apply it spontaneously. When you find yourself trying new things and not locked into a particular way of working, then rest assured you are on the right track. You can never fully express yourself by adapting the formulas or methods of others. Singing someone else's song may teach you a lot about music, but it won't satisfy that yearning deep inside to sing your own song, to be an artist.

Looking at the art world, it would be easy to conclude that everything has already been done. Perhaps it has, but not by you! What you have to offer is your own unique perspective. No one else sees or feels things in quite the same manner that you do. Painting gives voice to your experiences; it is the yearning to express yourself that invites such a long and arduous task as learning how to paint.

Each of us must decide for ourselves how to use the language of painting. When considering the overall direction of your work, there are no wrong choices. A good way to discover your natural inclination is through the kind of work you are drawn to in a gallery or museum. You may respond strongly to the painting style of Monet or Van Gogh, or perhaps to Vermeer or Velazquez. This is an indication of a path already laid out for you. As Joseph Campbell would say, "just follow your bliss."

It is a privilege to have the opportunity to express ourselves through art. That desire is the one thing that we all share. It links us to the great brother- and sisterhood of artists—past, present and future—as kindred spirits. I believe that the desire to create is innate to us all. The work that we do is not only positive and life-affirming, it also leaves us as better individuals and the world as a more positive place.

INDEX